1991

# THE MODERN MUSE:
## The Support and Condition of Artists

Edited by C. Richard Swaim

**ACA BOOKS**
American Council for the Arts
New York, New York

**ACA Arts Research Seminar Series Coordinator: Sarah Foote**

©Copyright 1989 American Council for the Arts

Edited by Bruce Peyton
Jacket design by Joel Weltman, Electric Pencil Studio

Director of Publishing: Robert Porter
Assistant Director of Publishing: Sally Ahearn

**Library of Congress Cataloging in Publication Data:**

The Modern Muse/edited by C. Richard Swaim.

(ACA Arts Research Seminar Series; 5)
1. Art patronage – United States. 2. Artists – United States – Marketing.
I. Swaim, C. Richard. II. Series.
NX711.U5M6  1989                338.4'77'00973                88-34391
ISBN 0-915400-75-8 (pbk)

*The ACA Arts Research Seminar Program*
*was made possible by a generous grant*
*from the Reed Foundation,*
*the John Ben Snow Memorial Trust and*
*the New York Community Trust.*

# CONTENTS

## ABOUT THE EDITOR

**C. Richard Swaim** is currently an associate professor of government and public administration at the Yale Gordon College of Liberal Arts, University of Baltimore, where he has served in the capacity of both a professor and a dean since 1977. He is the coauthor of *Public Policy and the Arts*, a book which highlights cultural policy and the arts. He has also published in several journals including the *Journal of Aesthetic Education; Gerontology and Geriatrics Education,* and *Policy Studies Journal.* Swaim holds a Ph.D. from the University of Colorado and an M.A. from Villanova University.

# ACKNOWLEDGMENTS

This fifth monograph in ACA's Arts Research Seminar Series seeks to shed light on the role and condition of the individual artist in the U.S. today. The book emanates from presentations and discussion at a seminar entitled "The Individual Artist: Condition and Support" held at the Walters Art Gallery in Baltimore in March 1988. Increased research about the artist was a major recommendation of the ACA-convened National Planning Committee on the Originating Artist. Hence, that seminar and this book.

We are privileged to have C. Richard Swaim as the editor of this volume. Without his dedicated and enthusiastic efforts this volume would not have been made possible.

We would also like to express a deep note of gratitude to the authors and participants who have shared their thoughts and experiences about the current climate for artists with intelligence and insight: Richard H. Brown, John P. Robinson, C. Lynn Cowan, Thomas F. Bradshaw, Bruce L. Payne, Ruby Lerner, Brann J. Wry, George Koch, Muriel Cantor, Ted Potter, Stephen Benedict, Charles Bergman, Judy Baca, Sanford Hirsch, Barbara Price, and Don Russell.

Finally, we are deeply indebted to the Reed Foundation, the New York Community Trust, and the John Ben Snow Memorial Trust, whose financial support have made this monograph possible.

SARAH FOOTE
Coordinator
Arts Research Seminars

# PREFACE

This monograph is based on "The Individual Artist: Condition and Support," an ACA research seminar held at the Walters Art Gallery in Baltimore in March 1988. Designed to enhance the discourse on critical issues in arts policy, the ACA seminar series brings together arts researchers and professionals involved with arts policy. Their goal is to shed some light on what is being done and identify what needs to be done next.

Two questions shaped the theme of this seminar: "What is the condition of the artist in America?" and "What support now exists for artists?" We were interested both in current conditions and in what the future might hold. A wide range of views were presented about the condition of the artist today and artist employment in the future. These presentations demonstrated the need for cautious interpretation of the data and for additional refinement of available data on the artist's condition.

The discussions that followed the formal presentations were equally instructive. The presentation examining the extent and quality of support available for older artists provoked a wide-ranging discussion of the need for support for artists of any age, and how that support could best be provided. Institutional support for individual artists stimulated a particularly fruitful exchange. Insights and suggestions were offered concerning the character of support available from art centers, colleges of art, foundations and artists' organizations.

The manner in which the seminar was conducted is important to what was gained from that day and to what is contained in this volume. At the seminar, the formal presentations were followed by reactions from invited discussants, and then by questions and comments from the audience. Both the formal papers and the transcribed remarks of discussants and audience members are included in this volume. The text of the papers is primarily as originally composed, with editing restricted to voice, verb tense, and transition. The transcribed remarks were more heavily edited to enable the reader to follow the conversations more easily.

In retrospect, the amount of information which emerged that day is stag-

gering. The papers established a context and a basis for discussion as well as for questions and comments from the audience. All these elements in combination yielded new insights into the artist's condition and a broader awareness of the support available for artistic enterprise.

The aim throughout this series of seminars has been to encourage discussion of important issues in arts research and arts policy as an aid to those who are charged with making informed policy decisions. On the topic of "The Individual Artist: Condition and Support," we hope this volume achieves that goal.

Many people made this volume possible and I would like to acknowledge their contributions. Sarah Foote, the coordinator of the Arts Research Seminar Series, made my life much easier by organizing all the details from New York. James Butler, my graduate assistant, organized the seminar in Baltimore. The Walters Art Gallery graciously allowed us to use the Graham Auditorium, and the Yale Gordon College of Liberal Arts of the University of Baltimore enabled me to undertake the project through a sabbatical leave.

Fred Lazarus, president of the Maryland Institute, College of Art; Madelyn Irving, director of School 33 Arts Center in Baltimore; and Charlotte Murphy, executive director of the National Association of Artists Organizations, contributed their ideas to the early development of the seminar and deserve my thanks. Thanks also to my friend and colleague at the University of Baltimore Derral Cheatwood for his Friday afternoon advice.

The authors of the papers contained herein, the discussants, and the seminar's audience deserve a lion's share of thanks for participating in the seminar and sharing their thoughts for this volume. I also need to single out Alice Simon-Curry, my editorial assistant, who assumed a great deal of responsibility in a very short period of time, transcribed the proceedings, and made sense out of a wide-ranging discussion, all of which enabled me to complete the work.

Finally, allow me to acknowledge the patience and support of Debra Kleyhauer Swaim.

C. RICHARD SWAIM

# INTRODUCTION

## by C. Richard Swaim

What is the condition of the artist in America today? What support exists
for the artist? These are the key questions that guided this work, and they
have many facets: Who are the artists? How many artists are there? How
are they doing? How are they being supported? What is the climate for art
and artists today? What will it be like tomorrow? These are difficult and im-
portant questions. Addressing them at the seminar, we learned that we
know the answers to some but not to others. We found new ways of ap-
proaching the subject. We discovered disagreement about the "numbers."
In fact, some of us doubted whether or not the condition of the artist could
truly be discerned. To address the topic, we began with a discussion of the
environment in which artists live and work.

## ART AS A COMMODITY

We live in a culture whose political economy structures our relationship
to our work. This political economy simultaneously offers us opportunities
and obstacles. It creates agencies to support us and, at the same time,
bureaucratic mazes and legal obstacles that frustrate even the most patient
among us. Dominating this environment is the marketplace, which is where
we begin our consideration of the artist's condition.

In the opening essay, Richard Brown talks about the gradual transforma-
tion of art into a commodity as it was removed from the context of everyday
life. The environment in which artists live and work, the function of art and
the role of the artist in society are key issues in a discussion of what it is like,
and what it means, to be an artist. For those who admire, envy, worship, sup-
port, fund, depend on and criticize artists, this is where the discussion
begins. In our society, is being an artist like being a plumber or a teacher?
Does the marketplace make artists any different than the rest of us — those
of us in ordinary occupations, individuals whom economists label as risk-
adverse, income-seeking individuals? What does the larger picture, the
political economy of our society, have to say to the artist? What does it

mean for art and for our definitions of artists and art?

This larger picture is fraught with the weighty ideological and philosophical issues of contemporary social and political thought. Richard Brown brings us foursquare with these issues in his assault on contemporary American society, where art has acquired the status of investment commodity, resulting in "a shift in art from craft to industrial-style production." Brown continues: "A star system developed among artists; most were unemployed while a few became rich celebrities."

What does it mean when the commercial market guides the marketplace of art and ideas? Is it a problem? Judy Baca thinks so. As she said during the afternoon's discussion:

> We constantly make the very tiring assumption that the marketplace is going to take care of us. I served with Frank Murphy, from the Times Mirror Foundation in Los Angeles, on a visual arts task force for President Reagan's Commission on the Arts and Humanities, and at one point he said, "Throw the artist into the marketplace and we'll see the best artists." I think that's a prevalent thought, that we are supposed to make it in the marketplace. But I can't tell my older friends where to go for support because I know they're out of fashion. And neither do I know where all the younger artists are going to go — unless we change our thinking about what the function of the artist is in our society.

Brown argues that the artist — as creative entertainer, entrepreneur, overseer or visionary — exists in a world in which art as a commodity is purchased not for use value so much as for exchange value, which devalues those works not suited for marketing as exchange or investment commodities. Whereas in earlier times individual acts of patronage were aristocratic and thus indifferent to commercial concerns, today's individual art purchases very often are made as investments. Meantime, with the rise of the mass media — which Brown calls "the mind industry" — culture as a whole has been packaged as mass entertainment, and although this has resulted in a larger audience, it is an audience that responds to celebrity based on brand-name recognition. High culture has become "a set of canonized musical scores, great books or blockbuster museum shows." Aesthetic experience has been reduced to mass consumption, the artist to a producer dependent on unsympathetic commercial markets and an increasingly competitive philanthropic marketplace.

Given this context — the market structure and Brown's concept of the "commoditization of art" — what is the artist's condition? In the next section, three social scientists offer their views.

# THE ARTIST'S CONDITION

John Robinson summed up the situation as one of "more interest and less money," or in market terms, "more competition, less profit." However, he believes that ongoing demographic changes in the United States bode well for the arts, particularly the increasing proportion of the population that is better educated than previous generations, since education is the main determinant of arts appreciation and participation.

Robinson's conjecture is supported by recent Harris poll data which indicate that a significant number of Americans value artists' work and consider art an important part of the American social fabric—worthy, therefore, of society's support. Brann Wry, in the discussion following Robinson's presentation, related the poll's finding as reported in the *New York Times:*

> The survey, for the first time, examined public attitudes toward artists and found surprisingly widespread admiration. Majorities rejected stereotypes of artists as undisciplined, unfocused, or unable to do an honest day's work. And 84 percent agreed that artists are highly important to the life of this country.

This favorable popular attitude and a growing and receptive audience are matched by a continuing increase in the proportion of artists in the labor force. There are now more than one and one-half million persons in "artist occupations," compared to less than half that many in 1970—a growth rate greater than expected, given the concurrent rise in the number of college graduates.

In addition, there are now more opportunities for the general public to participate in the arts. The number of dance companies has increased, there are more musical concerts than before and museums and galleries have expanded their activities. Because the nation's economy is healthy, particularly for the "typical" arts attender/participant, more people have the means to take advantage of these new opportunities—the means but not necessarily the time. The Harris data show that arts institutions are now competing for audiences composed of individuals whose lives are busier than ever before, and while education may be a favorable correlate for interest and participation in the arts, the decline in leisure time has conspired to decrease attendance and participation figures for most arts activities.

This condition of more competition and less profit also applies to individual artists. Robinson's data show that the average artist's real earnings declined 37 percent during the 1970s, compared to an 8-percent decline for

the average worker in the overall professional-technical category. This condition is neither unusual nor new for artists, and Robinson emphasizes that the decline in earnings has not meant a decline in the number of artists. This means that artists continue to provide a large hidden subsidy for art, through unemployment, under-employment, dual careers and spouse's or mate's support.

George Koch, in his subsequent discussion of the findings presented during the morning sessions, offered a useful way of thinking about this. He spoke of five conditions unique to the artist in American society, claiming that artists as a group:

> will spend more time and money educating themselves while in the work force than will other workers with the same amount of education. They will spend more of their disposable income on continuing education because, throughout their lifetimes, they are constant learners. Second, they will be unemployed more often. Third, their unemployment will last for longer periods of time. Fourth, in their lifetime they will work less as artists — as dancers, painters, musicians — than their counterparts will work as analysts or managers. Finally, and not surprisingly, artists will earn less in their lifetime than their colleagues in other occupations.

The outlook for artists in the Midwest, as presented by C. Lynn Cowan, bears out Koch's assessment. The conclusions Cowan draws from two separate studies are also similar to Robinson's regarding level of education and income. In addition, Cowan demonstrated that artists are, not surprisingly, entrepreneurs running one-person, labor-intensive small businesses. They can be aided by technology but are confronted with, and occasionally stymied by, bureaucracy. Using artists in the Midwest as her sample, Cowan found that conditions and concerns were similar among artists wherever they may work and live.

Still, regionalism has profound implications for artists within certain regions. Those living between the coasts are victims of the notion that one must go to New York or the West Coast in order to escape the label "regional artist." That good art can be produced anywhere, that regionalism — a sense of place — is neither a failing nor a limitation but rather a source of strength, was emphasized in the discussion that followed.

Notwithstanding the fact that, as Cowan notes, "the reality of the business is that art is shown and bought in New York," neither the art produced in the regions nor the organizations that address the needs of artists in places other than New York should be overlooked. Cowan argues that

regional arts organizations provide the infrastructure – the support system – that makes it possible for artists to live and work wherever they choose. In addition to fellowships, which give artists the time and money to focus on making art, the regional organizations have also been working to improve the environment and the market for art in their areas. This means recognizing area artists through shows, informed criticism, touring and programming. Cowan indicated that, through this spectrum of services, regional arts organizations hope to support and retain the artist populations in their areas.

Looking to the future, Tom Bradshaw reports that the growth rate in the "artist occupations" category of the labor force will be significantly greater than the rate for all civilian employment categories combined and slightly greater than the increase anticipated for the "professional workers" category, of which artists are a part. These artists will be part of a better educated and grayer America as the "Baby Boomers," the dominant population cohort in the next century, come of age.

## DATA PROBLEMS

Each of the presenters and many of the discussants noted the difficulty of acquiring useful and reliable data on artists. Said Robinson, speaking of the data available from the federal government, "Both of these sets of figures suffer from the fact that they were not collected with the arts in mind. In fact, no clear, comprehensive data on the nature of arts activity in this country are available." The problem is framed by what Robinson terms "Type 1 and Type 2 errors. Type 1 errors occur when people who do not belong in a category are mistakenly entered; in Type 2 errors, people who should be counted are overlooked."

Cowan expanded on the problems of data collection and interpretation:

It is well known that compiling accurate statistical profiles of artists is no easy task. When asked, "Which one of the following disciplines most closely describes your work in the arts?" some artists insist on marking two or more items or casting write-in votes. Mailing addresses are obsolete before they are entered in computer databases. Who could not sympathize with the discouraged fellowship applicant confronted with a form requesting the amount of depreciation on capital equipment? And what about the artists who did not receive surveys or were too busy creating art, or waiting tables, to respond? What about those who were too angry or not angry enough or too resigned? The situation is made worse by the fact that because of limited resources, data must

be collected for many purposes at once, and those who ask for the information often determine the distribution of arts programs and arts funding.

Concern with the quality of data marked the discussion throughout, emerging again as the seminar turned to the question of support for the artist. Both Jack Golodner and Sanford Hirsch stated that data were available from sources other than those currently being used, and that such data might prove to be more specific and more useful for policy making. Data available from the applicant pools of the Gottlieb Foundation and the Pollock-Krasner Foundation and information available from pension fund case histories were offered as existing data sets that might be of some use.

## SUPPORT FOR THE ARTIST

Support for the older artist was the topic that began the afternoon discussion. In an eloquent lecture, Bruce Payne addressed what he saw as the genuine and highly individual needs of mature artists, those who have worked at their art for most of their adult lives. Payne was joined in this discussion by Sanford Hirsch of the Gottlieb Foundation.

The vagaries of old age, the changing art market and the artist's often solitary work and life—these are the special problems associated with support of older artists. Failing health and the need for income security emerged as areas of concern that older artists share with many other older Americans. But for artists, who live and work without the infrastructure of support enjoyed by those in other occupations, the situation is especially precarious.

As is the case with older adults generally, independence and dignity are major concerns of older artists. Hirsch stressed that we need to consider these factors when we think about helping:

> Older artists have a problem not only with thinking of themselves as needy but also with thinking of themselves as older. They really don't want to have their position as artists, their self-esteem, their entire sense of self, denigrated to the status of being simply an older person. They view themselves as active, working individuals, and that's the way they need to be approached.

This concern was echoed by Charles Bergman when he spoke of those older artists who refuse to humiliate themselves by filling out applications that they are convinced will be rejected, and those who are not well enough to complete the forms, let alone to write narrative letters or send slides.

Hirsch went on to talk about the efforts of the Gottlieb Foundation on behalf of this special constituency:

The needs are so great that no matter how many programs we dream up, more will be needed. At the Gottlieb Foundation, we try to set up programs that will put dollars in the hands of individual working artists, without any strings: "You know what you are doing; you have been doing it for some time. We know you need help; here's some money. Do what you can with it." That's the best we can do right now.

Judy Baca reiterated her concern about the marketplace and its effect on older artists' lives: "Older artists should be models for me as a younger artist, but what occurs is that they go out of fashion. They reach a stage where their work is no longer an important commodity and does not sell."

George Koch pointed out that today's younger artists will be tomorrow's older artists, and he warned: "We seem to be focusing on those whose needs are most urgent, but at the same time we must not overlook the needs of other artists, lest they too become desperate. If there's a long line of artists marching down that same path, somebody ought to say stop."

## ARTISTS' ORGANIZATIONS AND INSTITUTIONS OF SUPPORT

The concluding session of the seminar began with Ruby Lerner's comprehensive account of the history, development and current status of artists' organizations, most of which developed during the seventies and early eighties. They represent a variety of disciplines — music, dance, theater and visual arts — and many of the artists' spaces that were originally founded to address the needs of visual artists have expanded to accommodate new interdisciplinary forms, such as performance art. Although the artists' organizations have played an important role in the arts explosion in this country, they have not received the recognition and support they deserve, Lerner said.

Shut out of existing venues — the commercial galleries, museums and regional theaters — many artists created their own alternatives to the "safe," established, traditional nonprofits. These new organizations hoped to attract audiences from diverse racial, ethnic and economic groups and, in so doing, to build a broad base of community support, rather than rely on the patronage of the wealthy few. Their founders had a new vision of the future, a new vision of art.

As the alternative spaces began to develop into bureaucratic institutions,

they were confronted with problems similar to those that had hindered the progress of their predecessors, the social movements of the sixties. Management, programming and support became major concerns. Energies were drained. Many organizations failed economically; others found they could no longer uphold their original mission. The dream of building an alternative culture began to slip away.

The decision to focus on local talent rather than "importing the work of 'stars' " was definitive. In some cases, this limited the potential for growth, but some alternative organizations experienced unexpected commercial success, and their problems were exacerbated by growth and expansion that came too rapidly. There was no time for appropriate "technical assistance," for reexamining organizational structure, for studying models of development. Those artist-founders who did make the time and find the resources to remake their organizations became absorbed in administration and thus had less time to make art. Their goal of functioning as the evolutionary change agents of a new social order became mired in internal institutional problems.

Lerner's message was that, in confronting these challenges, artists' organizations should not fall back on accepted corporate models of growth and development. They may need to reexamine the assumptions of past programs; they may need to reinvent the organization. Only by avoiding business world language — marketing, product, consumer, targeting — can they create organizational structures and models of development appropriate to artist-run organizations and remain loyal to founding principles.

Lerner emphasized that arts organizations must be aware of changes in the environment — demographics and population movement, use of leisure time, technological innovations, economic ups and downs — all of which affect the role of the arts in society. She urges artists to take note of these changes and to take responsibility for responding to them, lest artists and their artwork come to "perform a purely decorative function, becoming handmaiden to a social and business elite."

In the future, artists' organizations must face "contextual issues" that are crucial to effective decision making — while keeping in mind that their goal is the advancement of artists, not institutional self-perpetuation. Lerner stressed that there is no one correct course to follow, but whatever course is chosen, the choice must be an informed one: "The issue is really consciousness in the decision-making process. My concern is that a lot of organizations head in a direction without understanding the implications of the assumptions inherent in that direction."

Consciousness in decision making on the part of foundations, centers for art and colleges of art was the focus of the final presentations of the day. Charles Bergman of the Pollock-Krasner Foundation spoke of his organization's tremendous responsibility to be scrupulously fair in making awards, to be humane in the very "pretentious" act of designating which artists are "worthy or not, or needy or not." This sentiment was echoed by Ted Potter when he reminded the audience that "curators, administrators, directors and art dealers are all really flight attendants for this thing called art. We can lose touch with that sometimes, and we need to keep it in mind. Art and the creative artist are what it's all about."

Barbara Price outlined the comprehensive role played by colleges of art in the support of art and artists. Times have changed since the forties and fifties, she pointed out, and preparing artists to live and work in the reality of today is one of the most important functions of these institutions. Armed with BFAs or MFAs, today's young artists are prepared to cope with the different patronage structures that now exist. Colleges of art also play a central role in their communities, by participating in the economy, developing audiences and working with and supporting the artist community.

The last formal presentation was delivered by Don Russell, who began by observing that artists and society are much closer today than before, offering the preponderance of public art as the best example of this. He pointed out that one of the most important forms of support that an artists' organization can provide is the development of new and different audiences. But if we are to encourage the very best from the modern muse, we must give artists what they need most: time and money.

Throughout the seminar, participants sought to define the condition of the artist in America today, and to determine the nature and extent of the support available for artistic enterprise. Because the problems must be identified before solutions can be recommended, this seminar was an attempt not to solve problems but to lay the groundwork for positive change.

# artists and context

# ART AS A COMMODITY

## by Richard Harvey Brown

Art has become a commodity. It is now purchased not so much for use value as for exchange value. No longer an item of merely aesthetic, political or commemorative significance, it has become an investment. This quite recent historical development has profoundly affected the artist. Today's artist is no longer seen as a craftsperson, as in preindustrial times, nor as the seer or desperado pictured in the romantic counterimage of the industrial era. The commodity market for art has created a star system in which the successful artist has become both a mass-producer of icons for sale as investments and a commodity himself. The following arguments and examples illustrate the transformation of art and artist into commodity.

During the past several centuries, art began to be removed from the context of everyday life. Universal aesthetic values were created and the concept of art as a separate area of experience emerged. The mass media, or the "mind industry," also have helped make art a commodity, as have the promotional efforts of art dealers and critics. Increased liquidity of modern capital contributes as well.

As the art market grew, it fed on itself. Exhaustion of the supply of high quality artworks and the expansion of the art audience eliminated the prior oversupply, creating a relative scarcity of fine art and, hence, inflated prices and questionable evaluations and attributions — all of which reinforced the concept of art as a commodity. The emergence of a large tertiary sector of employment further enhanced the demand for art since these workers had more discretionary income for investments. Museums treated art as a commodity by mounting blockbuster shows and commercialized exhibitions.

These factors engendered a shift in art from craft to industrial-style production. A star system developed among artists. Most were unemployed

---

*Richard Brown is the assistant director of the Survey Research Center at the University of Maryland.*

while a few became rich celebrities. Currently, some artists are striking back by representing in their art, with conscious irony, the very system that seeks to debase them and their works, but even these protest pieces tend to become commodities. This situation appears to have no solution. Perhaps the self-empowerment of artists, their control of both the means of production and the consumption of art, would help.

## DEFINING THE AESTHETIC EXPERIENCE

Karl Marx, Max Weber, and Emile Durkheim each considered the application of the rational mind to social life an essential factor in the rise of capitalism and the bureaucratic state. They did not, however, comment on the introduction of market calculations into the art world. The definition of art as a distinct, universal experience was a necessary first step for art to become a commodity. In order to be exchanged in the marketplace, an item to be sold must first be apprehended independent of its context and then be assessed in terms of some universal value. In the Western world, art first emerged as a separate category of human experience only a few centuries ago. In earlier times and different places art was integrated into other areas of life—for example, in the form of architectural icons on temples, visual paeans to prelates or totems on functional objects.

The modern concept of aesthetic perception emerged only with the moral and religious debates of the seventeenth and eighteenth centuries. Central to this modern concept is "disinterested appreciation," an idea first articulated by Lord Shaftesbury in opposition to the "intelligent egoism" espoused by Hobbes. Actions motivated by fear of consequence or hope of reward—that is, interested actions—can have no moral value, Shaftesbury insisted, no matter how enlightened the self-interest might be. Shaftesbury contrasted disinterested appreciation of an object with any desire to possess or use the object. Aesthetic interest ends in the object on which attention is directed. A paradigm of this attitude, Shaftesbury said, is the enjoyment of mathematics, "where perception does not relate to any private interest of the creature, nor has it for its object any self-good or advantage."[1]

Religious experience was also used as a source for the definition of the aesthetic attitude. The notion of a disinterested love of God, for himself and not from hope of salvation or fear of hell, arose out of controversies between Jesuits and Jansenists. In a letter to the Scottish savant Burnet, written in 1697, Leibniz referred to a concern for the existence of things standing apart from our interest in their use:

He who finds pleasure in the contemplation of a beautiful picture and would suffer pain if he saw it spoiled, even though it belongs to another man, loves it so to speak with a disinterested love; but this is not the case with he who thinks merely of making money by selling or getting applause by showing it, without caring whether it is spoiled or not when it no longer belongs to him.[2]

A century later Kant expressed this idea in his concept of "aesthetic indifference." The artist was expected to have the same disinterested passion for truth and beauty that the scientist had. Salvatore Rosa was one of the first artists to display this spirit when he insisted that he painted "for his own satisfaction and pleasure rather than to please his clients."[3] Later, artistic ideologies distinguished "fine" from "applied" art, much as scientific ideologies separated "pure" and "applied" research. Fine art was esteemed because of the purity of its form and motivation; applied art was scorned as aesthetic prostitution.[4]

Artists sought the prestige that was offered to scientists and inventors, who now appeared to be contributing to modernization, state formation and industrial development. To this end, artists stressed the homogeneity of cultural forms, particularly the central role of mimesis in art and science, in order to justify their claim to the privileges enjoyed by scientists.[5] Thus Mignot, the late Renaissance architect of the cathedral of Milan, asserted that "ars nihil sine scientia est." This thought was later refined by Flaubert: "The illusion of truth comes from the very objectivity of the work." It was repeated in Constable's remark that "painting is a science of which canvases are experiments" and in Braque's search for "a method that would be appropriate for verifying paintings."[6] A dominant paradigm was emerging that seemed unique in inspiration, though universal in its products, and which devalued or subsumed other aesthetic approaches. This paralleled the link in capitalism between newness and consumption; that is, the invention of new products, combined with mass marketing, leads to mass consumption of standardized commodities.

Art produced by women, racial minorities or persons outside metropolitan centers was considered ethnocentric or regional. Such artists were expected to transcend the particulars of their race, gender or locale and to affirm those artistic standards that were taken as universal norms. That this aesthetic approach is still very much in force today is demonstrated by the comments of an artist participating in a panel called "Angry" at a recent Arts Association conference:

We all want to be universal, not regional. . . . Yet the current situation with regard to artists who are neither "East Coast" or "West Coast" . . .

in other words, "regional" artists — is that we face a geographic prejudice. . . . Many regional artists are unable to believe in their own, or each other's, validity; it's hard to when nobody else does. . . . We are so busy trying to prove we're "mainstream," whatever that is, that we don't see that there might be strength in being outside all of that.[7]

## ART AS INVESTMENT

As the market absorbed more and more areas of life, modern capital became increasingly liquid. Today more money is printed than formerly was minted. Cash and credit have both greatly expanded. The abstraction of things into commodities generally, and the abstract qualities of modern finance itself, both facilitate the swift conversion of one commodity into another, including assets into art.

Indeed, we have come to think of works of art themselves as investment assets or commodities. This was not the case two hundred years ago. Great art was always expensive, but the great fortunes of preindustrial Europe were land-rich and cash-poor. "To raise large sums of money you had to sell acreage, and when fortunes were frozen in entailed lands that was hard to do; to do it for the sake of a few square feet of canvas would generally have been considered improvident lunacy."[8]

Even in the nineteenth century, people bought paintings for pleasure, status or to commemorate events, not for investment. Before the twentieth century, art was purchased in the spirit of Veblen's dictum that, as a display of wealth, waste is efficient. Moreover, no one could get a tax write-off by giving their collection to a museum, since there was no personal income tax and few public museums. People did not view an extravagant purchase as a shrewd investment, but rather saw it as an aristocratic act, intentionally indifferent to commercial concerns.

## THE EFFECT OF MASS MEDIA

The rise of the mass media as a dominant cultural element also had an effect on art and the condition of the artist. The mass media, the "mind industry," gobbles up content, digests it and excretes it in standardized electronically sealed "baggies." The mind industry is capable of reducing any idea to a slogan, any sentiment to a cliche. The range of slogans and cliches is narrow and filled with stereotypes, inculcating in its audiences a rigid set of categories by which to perceive, assess and respond to their experience. As a result, culture is reduced merely to ideology, since it no longer contains the symbols that could be used to articulate dissent.[9]

In a dialectical fashion, however, the mind industry thrives on what it fears. It is nourished by what it seeks to suppress — free creativity. The industry tries to transform the traditional role of the artist or intellectual by turning art and ideas into a novelty or spectacle for sale. Seeing autonomous creators as a threat, it tries to co-opt them with promises of wealth. Thus, "high culture" becomes a set of canonized musical scores, great books or blockbuster museum shows. The public that consumes these products becomes an audience that relates little to the inherent properties of the artwork and even less to each other. Similarly, indigenous traditions are turned into folklore, so they can be more easily marketed.[10] For example, country music is now slickly packaged mass entertainment performed by new media stars. As audience response becomes disconnected from the concept of aesthetic merit, celebrity based on brand-name recognition replaces respect and admiration based on artistic achievement. Literary or visual artists themselves become performances. They and their works are known for being known, purchased because of their high price. Indeed, the phenomenon of being a celebrity is itself a kind of pricing system, a mechanism for assessing the market value of personality, independent of the inherent worth of artistic achievement or individual character.

## DEALERS AND CRITICS

A parallel development to art's becoming a commodity is the emergence of dealers and critics as arbiters of investment value. They function today as stockbrokers or analysts of the art market. Like brokers dealing in hog-backs, they advise clients to invest in art futures, to buy today and profit by donating tomorrow. This development was begun by Bernard Berenson and Lord Duveen. In some cases this duo made, or even made up, artists. One of Berenson's creations was Amico di Sandro.

There was, Berenson felt, one artist whose style combined the features of Sandro Botticelli and Filippino Lippi, with a dash of Ghirlandaio; he wasn't any of these but he leaned most heavily toward Botticelli. Berenson christened him Amico di Sandro and attributed a group of pictures to him. . . . [Amico's] market value in America went up steadily. One of the greatest American collectors paid altitudinous prices for him. But then Berenson began to disapprove of Amico. Nobody, Berenson felt, could be that good — so consistent, so distinctive. [Soon] Amico disintegrated. Berenson divided him into three parts; he gave part of him back to Botticelli, part to Filippino Lippi, and part to Ghirlandaio. The effect on the American collector who paid so high for Amico was catastrophic.[11]

Such manipulation of the market further stimulated demand, and soon the inventory of old, dirty, uncataloged, unrestored, undisplayed art was depleted. Once older artifacts had been cleaned up and marketed, attention was directed to lesser known masterpieces and unknown contemporary artists. Demand outstripped supply as the population of art consumers expanded, and museums became new crypts for paintings.

The expansion of demand for art for investment purposes was dependent on the creation of another cultural product: confidence, perhaps a more striking artifact than the works it serves to validate. Museums and scholars helped create confidence by providing pedigrees and shrines for selected masterworks. Their sister and cousin artworks then enjoyed price inflation due to family resemblance and the celebrity of sameness. Dealers became confidence men, not only offering surety of provenance but, more importantly, assurance that the market would continue to rise. The informal circles of artists that were so important in the establishment of the early Impressionist movement[12] are no longer central to the contemporary visual art world in Paris[13] or New York.[14] Instead, dealers have come to take on the role of taste-makers, and adoption by a leading dealer is an artist's ticket to exposure in the market.[15] Dealers are often quite explicit about their role in determining an artist's place in the market. "A client comes in and wants to know what that's worth," said one dealer pointing to a lithograph hanging in his office. "I'll tell him $2,500. If he asks me why, the real answer, the bottom line, has to be, because I say so."[16]

Now almost everyone with cash has gotten into the feeding frenzy for art. The British Railway Workers Pension Fund spent $1.5 million for a twelfth-century English gilt altar candlestick, presumably with no intention of using it to decorate the union hall. Modarco, an art fund based in Geneva, sells shares over-the-counter on the Swiss stock exchange. The magazine *ARTnews* compiled an "Investor's Guide to the Art Market" and issues a biweekly newsletter highlighting trends in auction prices, tax legislation and other topics of interest to investors. Similarly, *Connoisseur* magazine features an "Investor's File," which reviews newly discovered schools, periods or artists that have good price/equity ratios and upside potentials. The Sotheby art index reports putative statistics on the price movements of art objects from Tibetan bronzes to Italian Bronzinos. Of course, like most stock market news, these tips are obsolete before they reach their readers.

Scholarship, criticism, journalism, public relations, tax deductions and museum policy all contribute to the perception of an endless rise in the value of artworks. Scarcity of art objects and expansion of demand in turn stimulate further profit, confidence and demand. The inflation of prices has

a corresponding trend toward debasement of standards. Today the appellation of "priceless masterpiece" accompanies the request for opening bids on journeyman schlock. Outlandish prices seem valid and justified when published as the current fair-market value.

While the securities market is highly regulated, the art market is wide open to manipulation, price-fixing, conflict of interest, tax fraud, excessive commissions and misuse of insider information and public institutions. For example, a dealer invests in an artist by having shows of his work, publishing catalogs and arranging for publicity. Then, as one New York dealer explained:

> If a work by that artist comes up for auction, I stand to lose my entire investment if it goes for nothing. The artist might not have caught on with the public yet. The low auction price will make the market go soft, and it will take a lot more time and money to build the artist's reputation again.

To protect his stake, the dealer attends the auction and bids up the artist's work at the auction and thereby at his gallery. If necessary, the dealer buys the work himself. Such price-fixing is usually illegal according to laws regulating securities. It is common in the art world. As in a securities pool, dealers and investors bid up the price of a stock or artwork, "frequently selling back and forth to each other, creating an atmosphere of frantic excitement. When the pool is broken, the insiders sell first, and the price falls drastically. In the art business this practice is easy to disguise, and the prices seldom fall since the devalued works of art will almost certainly disappear from the market into collectors' attics once the promotion dies."[17]

## CULTURE AS BIG BUSINESS

The increase in art consumer-investors has several components. The general audience for art is much broadened now that galleries, museums and auction houses have become low volume forms of mass entertainment. In addition, the number of people trained in the arts has grown exponentially. Art schools graduate some 40,000 persons per year, about as many adults as there were in Florence around 1500. Has this bred a new Renaissance? The answer is an emphatic no. The result has been a great number of unemployed artists at the bottom of the field and a star system at the top.

The fabulous prices paid for celebrity works and the fabulous incomes of art stars are much touted in the press. But the great majority of artists cannot even make a living from their work. For example, government data on various artists occupations for 1970 and 1980 revealed that the number of art workers had increased by 48 percent, whereas their earnings during this

period had decreased by 37 percent.[18] In 1980, the average income of an artist living in Massachusetts was $13,008, of which only $4,535 was income earned from art. No other occupation has such highly trained people who must earn most of their penurious incomes outside their field.[19] This bottom level of the expanded art market is made up of persons with more taste than money. The opposite is true at the top level — more new money, new collections and newly old masters than taste.

Due to the large, and largely uncritical, demand for art, the art industry has become like the fashion industry. In the 1940s and 1950s, for example, there was a new avant-garde every three years. Since then, the succession of artistic fads has become much more self-consciously contrived.[20] New styles must be created each year, and works in those styles produced in volume. With associations of galleries selling their work simultaneously in New York, London, Zurich, Paris, Milan and Tokyo, art stars must work on an industrial scale. The stakes are high for it takes two paintings a week to fill these galleries' walls. Thus emerges the new academy of the spray can.

Culture has become big business. The economic health of Hamburg or Munich is at stake, for example, when only one city can become the capital of German-language records and films. The tertiary sector of the economy — production requiring large amounts of knowledge and technology — is made up of well educated "yuppies" in America, and "chikie-mickies" in Germany. These people can only be attracted to live and work in would-be Silicon Valleys if opportunities exist there for cultural consumption. For this reason, more new museums have been built in Germany in the past decade than since the creation of that nation. All these trends expand the audience and consumer base for art as a commodity.

## THE MUSEUM'S ROLE

Art was first sold as a concept, then as a commodity; first as an object of appreciation, then as an investment. The sale of art as a commodity was perhaps most energetically undertaken by precisely those guardians against commercial values, the museums. The transformation of museums into brokerage houses and sales emporiums is reflected in the Art Institute of Chicago's decision to copyright the maquette of a statue donated by Picasso for the purpose of obtaining revenue from its reproduction.[21] By buying and exhibiting the works of older or dead artists, museums influence the resale market for those works. When they buy and show the work of younger artists, they can make the artists and influence the market for contemporary works.[22]

The new East Wing of the National Gallery in Washington sends out an implicit message about art. The very sumptuousness of the East Wing suggests an ultra-chic shopping mall. The blockbuster shows are designed to overwhelm the visitor, to send him reeling from each exhibit. The show titles suggest opulence as well, for example "The Splendors of Dresden" or "The Treasures of Tutankhamen."[23]

Perhaps this trend began when the Metropolitan Museum of Art paid $2.3 million for Rembrandt's *Aristotle Contemplating the Bust of Homer* and displayed it with a red velvet sash. *Time* magazine printed the painting on its cover surrounded by a gold border, thereby suggesting the embrace of art and wealth. The era of exhibitions of art masterpiece-as-treasure had begun.

The Metropolitan Museum has become an arrogant and gross storehouse for art. Everything must be possessed, from all periods and all places. Twenty years ago the Met was fairly quiet. The collections, though smaller, were arranged so as to educate the mind and elevate the spirit. Today they dazzle the beholder, conveying the commercial value of the art. The big traveling exhibits are promotional efforts designed to turn a profit for their sponsors. What is a show such as "The Treasures of the Vikings" but a tourism promotion for Norway? A large exhibit of Chinese art was financed in part by Mr. Bloomingdale, who hired American designers to create chinoiserie, retail goods based on motifs from the show. These designs were manufactured in China, then imported and sold by Bloomingdale's department store. Thus these retail objets d'art were promoted by the exhibit and vice versa.

In the same spirit of commercial egoism, the Lehmann collection is housed in a relatively new wing, unrelated to the Met's regular holdings. It is like a shrine to the banker's memory and money, including portraits of the donor and reproductions of some parts of his home, where the works were originally displayed. Lehmann's medieval and nineteenth century paintings should have been integrated into the Met's basic collection. Instead they constitute a mini-museum within the Met.

The Met is a source of highs and lows like an overly sumptuous meal. Hoving made the Met an "in" place to go. He expanded the collections, brought in people and money, and made himself an art czar. And rather than conveying aesthetic values to a broad public or challenging complacent assumptions, Hoving promoted art as a commodity. The objects are still splendid, sometimes even more splendid than before, but their organization, presentation and promotion create a context that reduces aesthetic experience to mass consumption.

## THE EFFECT ON ART

This attitude has affected the character of art. In the post-modern period, artists have tended to react against such commercialized culture. Contemporary art is based on the premise that codified meaning is corrupt, man is unknowable and the world is absurd. The question is no longer "What is self and society?" but rather "How is meaning manufactured, how is identity patched together, how is reality constructed?" Past (causality and motivation) and future (telos and destiny) are collapsed into the present acceptance of absurdity and choice.

War, for example, had a clear, intelligible meaning from the time of Homer to Tolstoy. Helen or Russia was at stake. But in the contemporary period, Good Soldier Schweik and his comrades go to war without knowing, or even caring, why. As in Kafka's "Metamorphosis," one can change from person to cockroach overnight. Socially stable meaning died first as a given, then as a possibility, and finally as a significant category of human experience. Postmodernists reduce meaning and nonmeaning to a relative sameness. The world represented in postmodern art becomes a "network of neutral and purely contingent relationships."[24] Contemporary narratives tend to have a self-referential structure, as in Alain Robbe-Grillet's anti-novels, for example.

The opposition of science and art, or of processed media culture and authentic human experience, is collapsed in the post-modern perspective. This is illustrated by a comparison of the views of Lewis Mumford and John Cage about technology. Mumford associated technology with the impersonal, regular, efficient and uniform. But in rejecting these values, Mumford accepted the terms and categories of the modern technological society that he criticized. By contrast, Cage sees technology as pregnant with aesthetic values of heterogeneity, randomness and plenitude. "Since the theory of conventional music is a set of laws exclusively concerned with 'musical' sounds, having nothing to say about noises, it has been clear from the beginning that what was needed was a music based on noise, on noise's lawlessness."[25] Cage incorporated technology into a postmodern aesthetic and, in so doing, undermined the entire debate between Mumford and others arguing for or against modernism.[26]

This postmodern spirit is expressed in pictorial art by such artists as Magritte, Escher, Dali and Oldenburg. In his *Portrait of Gala* (1935), for example, Dali starkly rendered three distinct planes:

> ... with no effort to link them illusionistically, thereby calling attention

to their interaction purely as surfaces in complex relations of identity and difference. Incongruity is the dominant feature of the painting. . . . This materialism is not a naturalism; it maintains mystery, but the mystery must be earned entirely within empirical models of perception. Then it becomes the idealist who fails the spirit of art by ignoring the mind's dependencies on the effects of perceptual and semantic surfaces (or codes) in tension.[27]

Dali created a surreal world filled with irony; for example, he shattered linear time by portraying melting watches. Similarly, in Justen Ladda's work, boxes of Tide, Clorox and Fab are made sacred in a gigantic image of Dürer's *Prayer.*

On the one hand art is depersonalized; on the other, artists today can become flamboyant narcissists. Rothko depersonalized his artworks with a new aesthetic of exclusion: no texture; no brushwork or calligraphy; no sketching or drawing; no forms, design, space, time; no movement, size or scale; no symbols, images or signs. These works reflect contemporary society while they criticize it. This characterizes the work of playwrights such as Beckett, novelists like Sarraute or Robbe-Grillet and composers such as Cage. At the other end of the continuum, however, are artists who make themselves the product: Truman Capote, Norman Mailer, or visual artists like Parr, who uses violence to "get the public implicated."[28] Just as Claes Oldenburg's gigantic mitt hyperbolizes the American myth of baseball, so, too, Parr's grotesquely enlarged self-image mocks the American celebration of the self.

Such criticisms of contemporary society pose no threat to the system. Rather, these protests are marketed along with other artworks, and the postmodern aesthetic is defeated. The very relativity of postmodernism reflects the relativity of the marketplace, rather than any absolute. As Andy Warhol said, "Good business is the *best* art."[29] Thus, postmodern artists — acting as entrepreneurs or as overseers — join other members of the art world in facilitating the sale as commodities of cultural products. Even they seek to shock only insofar as it results in personal profit and fame. The skepticism and despair of postmodernism can be seen as the result of disillusionment with modernism. But perhaps such skepticism and despair more truly reflect the diffusion of capitalism within the cultural community itself.

## NOTES

I wish to thank Remi Clignet, Richard Peterson, John Robinson, June Wayne, Josephine Withers and Giovanna Zincone for their critical com-

ments on drafts of this essay and for numerous ideas and insights that are not specifically acknowledged in the text.

1. Harold Osborne, *Aesthetics and Art Theory: An Historical Introduction.*(New York: Dutton, 1968), p. 154.

2. Ibid, p. 1179.

3. F. Haskell, *Patrons and Painters.* (New York: Knopf, 1963), pp. 22-23.

4. Remi Clignet "On Artistic Property and Aesthetic Propriety," (Mimeo. Department of Sociology, University of Maryland, College Park, 1988), p. 8. See also, W. Ivins, *Prints and Visual Communication.* (Cambridge: MIT Press, 1969).

5. R. Caillois, *Approches de l'Imaginaire.* (Paris: Gallimard, 1974), pp. 28-29.

6. Remi Clignet, *The Structure of Artistic Revolutions.* (Philadelphia: University of Pennsylvania Press, 1985), p. 96, and Remi Clignet, "On Artistic Property and Aesthetic Propriety," (Mimeo. Department of Sociology, University of Maryland, College Park, 1988), p. 6, and Richard Harvey Brown, *A Poetic for Sociology: Toward a Logic of Discovery for the Human Sciences.* (New York: Cambridge University Press, 1977), pp. 34-47.

7. Leila Daw, "Viewpoint of a Regional Artist," *Art Link Letter* (February, 1987), p. 2.

8. Robert Hughes," On Art and Money," *New York Review of Books,* December 6, 1984, p. 21.

9. Hans Magnus Enzensberger," The Industrialization of the Mind," in *The Consciousness Industry.* (Boston: Seabury Press, 1974).

10. Kingsley Widmer, *The End of Culture.* (San Diego: San Diego State University Press, 1975).

11. Samuel Nathaniel Behrman, *Duveen.* (New York: Vintage Books, 1952), pp. 156-157.

12. M. Bernier, *L'Art et l'argent: Le Marche de l'art au XIX siecle.* (Paris: Robert Laffont, 1977).

13. Raymonde Moulin, *Le Marche de la Peinture en France.* (Paris: Editions de Minuit, 1967).

14. Charles R.Simpson, *SoHo: The Artist in the City.* (Chicago: University of Chicago Press, 1981).

15. Richard Peterson, "The Sociology of Art and Culture in America." (Mimeo. Department of Sociology. Vanderbilt University. Nashville TN, 1987). See also, Sharon Zurkin, *Loft Living: Culture and Capital in Urban Change.* (Baltimore: Johns Hopkins University Press, 1982).

16. Deborah Trustman, "The Art Market: Investors Beware." *Atlantic Monthly* (1987), p. 19.

17. Ibid., pp. 74-75.

18. "Labor Force Data on Various Artists Occupations," (Research Division, National Endowment for the Arts, March 1988).

19. *American Artist Business Letter* (December, 1982), p. 7. And, Neil O. Alper, *Artists in Massachusetts: A Study of Their Job Market Experiences.* (Massachusetts Council on the Arts and Humanities, 1981), p. 7.

20. Diane Crane, *The Transformation of the Avant Garde: The New York Art World, 1940-1985.* (Chicago: University of Chicago Press, 1987). See also, Richard Peterson, "The Sociology of Art and Culture in America." (Mimeo. Department of Sociology. Vanderbilt University. Nashville Tennessee, 1987). And, Charles R. Simpson, *SoHo: The Artist in the City.* (Chicago: University of Chicago Press, 1981).

21. Remi Clignet, "On Artistic Property and Aesthetic Propriety," (Mimeo. Department of Sociology, University of Maryland, College Park, 1988), p. 21.

22. Howard Becker, *Art Worlds.* (Berkeley: University of California Press, 1982). See also, Diane Crane, *The Transformation of the Avant Garde: The New York Art World, 1940-1985.* (Chicago: University of Chicago Press, 1987). And, Richard Peterson, "The Sociology of Art and Culture in America." (Mimeo. Department of Sociology. Vanderbilt University. Nashville Tennessee, 1987); Gene Metcalf, "Black Folk Art and the Politics of Art." pp. 169-194 in Judith H.Balfe and Margaret Jane Wyszomirski, eds. *Art, Ideology, and Politics.* (New York: Praeger, 1985); Karl E. Meyer, *The Art Museum: Power, Money, Ethics.* (New York: William Morrow, 1979); Allem J. Whitt, "Mozart in the Metropolis: The Arts Coalition and the Urban Growth Machine," *Urban Affairs Council* 23, (1987), pp. 15-36; Vera Zolberg, "American Art Museum: Sanctuary or Free-for-All," *Social Forces* 63 (1984).

23. Josephine Withers, "In Search of the Magic Kingdom," *New Art Examiner* 9, (October 1981), p. 1.

24. Eric Leed, " 'Voice' and 'Print': Master Symbols in the History of Communication," p. 35 in Kathleen Woodward, ed. *The Myths of Information: Technology and Cultural in Postindustrial Culture.* (Madison, Wisconsin: Coda, 1980).

25. John L. Cage, *Empty Words.* (Middletown, Connecticut: Wesleyan University Press, 1981).

26. Thomas Streeter, "Some Thoughts on Criticizing the Information Society." (Paper presented to the Fifth International Conference on Culture and Communication, Philadelphia, 1983), p. 12.

27. Charles Altieri, "Surrealist 'Materialism.' " (Paper presented to the conference on Dali, Surrealism, and the Twentieth Century Mind, St. Petersburg, Florida, February 1983), p. 3.

28. S. Gablik, *Has Modernism Failed?* (New York: Thames and Hudson, 1985), pp. 49-50.

29. *Newsweek,* "The Selling of Andy Warhol." (April 18, 1988), pp. 60-72.

# the artist's condition

# ASSESSING THE ARTIST'S CONDITION: Some Quantitative Issues

## by John P. Robinson

Is arts activity and appreciation increasing or decreasing today? By several accounts, it seems to be increasing. A growing proportion of the population is college educated, the main determinant of arts appreciation and participation,[1] and the proportion of the labor force identifying themselves as artists has been steadily rising as well. There are now more than one and one-half million people in "artist occupations," compared to less than half that many in 1970, a growth rate that is greater than expected, given the increase in college graduates during this period.

## GOVERNMENT LABOR FORCE DATA

Using criteria established by the National Endowment for the Arts, Table 1 shows the various categories of artist occupations in 1987 and the proportions of the labor force in each. According to these criteria, artists comprise about 1.3 percent of the total labor force and over 10 percent of the workforce in professional-technical occupations. Also, more than a third of the artist workforce are classified as designers, while painters, sculptors, musicians, composers, architects, photographers, actors, directors and dancers each constitute between 6 and 13 percent of the artist labor force. (The criteria used to determine categories of artist occupations is of crucial concern in relation to the arts. More will be said about this later.)

This summary of occupational data on artists shows that the proportion of people in artist occupations increased 62 percent between 1970 and 1982, compared to a 25 percent growth of the total workforce and a 52 percent increase in professional-technical workers. This overall increase masks sig-

---

*John P. Robinson is a professor of sociology and the director of the Survey Research Center at the University of Maryland.*

## TABLE 1: Labor Force Data On Various Artist Occupations

| Artist Occupation | 1987 Numbers | Percent | Annual Growth 1970-80 (Census) | Annual Growth 1983-87 (BLS) | 1980 Percent Women (Earnings) | Changes In Real Earnings 1969-79 |
|---|---|---|---|---|---|---|
| **Visual Arts** | | | | | | |
| Architects | 136,000 | 9 | 10% | 7% | 8(54) | -24 |
| Designers | 546,000 | 35 | 4% | 8% | 50(37) | -87* |
| Painters/Sculptors,etc. | 198,000 | 13 | 8% | 1% | 48(48) | -62* |
| Photographer | 131,000 | 8 | 4% | 3% | 23(43) | -34 |
| **Performing Arts** | | | | | | |
| Actors/Directors | 98,000 | 6 | 6% | 10% | 34(65) | +7* |
| Radio-TV Announcers | 62,000 | 4 | 8% | 12% | 18(74) | -42 |
| Dancers | 16,000 | 1 | 8% | 8% | 75(66) | -18 |
| Musicians/Composers | 177,000 | 11 | 4% | 1% | 30(45) | -5 |
| **Other** | | | | | | |
| Authors | 86,000 | 6 | 7% | 9% | 44(45) | -60 |
| Art Teachers (Univ) | 41,000 | 3 | -3%† | 1% | 48(41) | -35 |
| Other Artists | 67,000 | 4 | 1% | 1% | 40(52) | -47* |
| **All Artists** | 1.6 million | 100% | 5% | 5% | 38(42) | -37 |
| **All professional technical workers** | 14.7 million | 10.5% | 4% | 3% | | -8 |
| **Total workers** | 119.9 million | 1.3% | 3% | 2% | 43(70) | NA |

*Estimate may not be accurate because of significant changes in definition of occupational category in 1979.
†Estimate

Source: Various reports prepared by the National Endowment for the Arts

nificant differences between artist occupations. Architects, authors and dancers increased their numbers significantly, while musicians/composers and photographers showed below-average growth. The number of teachers of the arts actually declined. The proportion of women varies widely from one artist occupation to another. Only 8 percent of architects and 18 percent of announcers are women as opposed to 75 percent of dancers. Also, women earn far less money than male artists in each category.

Despite the overall growth in artist occupations, the final column of Table 1 shows that the artist's real earnings declined 37 percent during the 1970s (the latest dates for which data are available) compared to a decline of only 8 percent for professional-technical workers as a whole. This suggests an interesting and familiar trend as far as artists in America are concerned, a trend which may be summarized as *more interest, less money*. It might also be characterized as *more competition, less profit*. Although declining earnings in the arts have not decreased the number or proportion of artists in this country, there may be thousands of aspiring artists who have pursued other careers as a result of the poor prospects for making a living in the arts. A similar picture emerges from government data on patterns of money expenditure: the total amount of money spent on art-related activities and objects is no greater a percentage of our gross national product than a decade or two ago.

## PROBLEMS WITH EXISTING DATA

Both of these sets of figures suffer from the fact that they were not collected with the arts in mind. In fact, no clear, comprehensive data on the nature of arts activity in this country are available. For example, how many of the 1.6 million individuals counted as artists in Table 1 have produced a significant or lasting piece of serious art in the last five years or will produce one in their lifetime? This seems an especially pertinent question in reference to designers, the largest group in Table 1, which may include people who work for K-Mart or McDonalds, or the designers of the shower handles that alternately scald and freeze us each day. The question may also be posed for the photographers, announcers and authors counted as artists. And how many of the 136,000 architects and the 177,000 musicians are engaged in even minimally creative or original activity? How many have influenced other artists or citizens to see the world differently than they would otherwise have seen it?

On the other hand, these surveys probably *missed* counting many artists who were forced to support themselves with nonartistic occupations. Charles Ives and Herman Melville were office workers as well as great art-

ists; Mark Twain and Ernest Hemingway were journalists for much of their lives. How many of their modern-day counterparts are ignored in these data?

These are difficult questions, and they may be unanswerable even by more definitive, more comprehensive data. Survey research statistics inevitably involve what statisticians call Type 1 and Type 2 errors. Type 1 errors occur when people who do not belong in a category are mistakenly entered; in Type 2 errors, people who should be counted are overlooked. The first are "sins of commission," the second "sins of omission."

Both types of error can be addressed indirectly by simple, straightforward research efforts. Some interesting and provocative data addressing Type 2 errors (sins of omission) already exist, and these data should be used as a starting point for a larger and more sensitive inventory of all arts activity in this country, including an attempt to reduce Type 1 errors (sins of commission) as well. A full population survey could be used to estimate all artistic activity. The next step would be to examine the content of such activity. Was any creative or original effort involved? According to the artist, what were the standards of performance, and were they achieved?

Three preliminary, fragmentary studies of this type have been conducted. All indicate a significant amount of arts-related activity that is undetected in labor force and expenditure surveys, that is, Type 2 errors. The first consists of all arts-related activity reported in the Americans' Use of Time Studies, in which members of the public report all their activities during a typical day. Surprisingly, in the three national time-use studies conducted in 1965, 1975 and 1985, the amount of time individuals reported they were engaged in some arts-related activity, such as playing music or writing poetry, was greater than the time they spent attending cultural events or visiting art museums.[2]

Similar conclusions were reached in the larger Survey of Public Participation in the Arts of 1982 and 1985.[3] In both years, about 3 percent of the public said they had performed in a musical event, play or dance during the previous year. These figures are more than ten times larger than the total number of performing artists described in Table 1. While the level of artistic performance for this 3-percent segment of the public may be lower than that of the arts professionals in Table 1, the figure does indicate a significant amount of previously uncounted arts-related activity. This offers an appropriate starting point for a truly comprehensive survey of the condition of the arts in this country.

The third study was the ARTS '83-'84 survey, conducted in June 1983

and January 1984 from a random national sample of more than a thousand American adults.[4] The survey covered a broad range of arts activity and experience, including the names and details of arts performances the respondents had attended; their level of arts information and appreciation, especially in relation to music and the visual arts; and the number of art objects they possessed in their home. The study found that 38 percent of the respondents felt they could play a musical instrument. Of those, almost a third (12 percent of the entire sample) felt they could play well enough to play with other musicians, or that they could read music at a good or excellent level. An additional 25 percent felt they could sing. Another 33 percent felt they could draw in perspective (12 percent said at an excellent or good level), and 16 percent said they had done creative art work or taken art lessons during the previous year. About 20 percent felt they could do ballet or modern dance, half of them at a good or excellent level. Another 20 percent felt they could do creative writing. Altogether, some 6 percent freely mentioned an arts-related activity as something in which they had developed a particular leisure-time skill.

These three studies are quite preliminary. They need to be elaborated to produce a full picture of national arts activity and to reduce Type 2 errors (sins of omission) regarding important arts activity not reflected in present occupational statistics. Type 1 errors could be reduced by a national survey of people working in the artist occupations listed in Table 1. People in "fringe" occupations — for example, journalists or art dealers — should also be surveyed, since their work can involve serious artistic accomplishments as well. Unlike earlier surveys, this proposed new national survey of artists would include focused, detailed questions designed to identify recognized artists — the most prominent in the country — according to peer nomination and reputation. In addition, some measurement of the level of artistic aspiration and aptitude would be attempted through the corroboration of self-reports by peer judgment. Such a survey would provide a much more realistic, fine-grained picture of the artist population.

Certain relationships can be hypothesized about this more elaborate survey of artists and levels of artistic activity. The latter occurs in nonartist as well as artist groups, although far less extensively. With serious art, production is inversely proportional to the size of the work force in both artist and nonartist occupations. High-quality artistic output is most likely to occur among those artists with the reputation of "innovator" or "genius," followed by those with the reputation of "leading artist," though the survey would not be confined to artists in those categories. In both artist and nonartist occupations, there are large numbers of workers with unused and possibly wasted art skills, and some attention ought to be paid to the arts-related

needs of this relatively large segment of the population, even if it is only to recognize their existence. These hypotheses, until tested by the new survey, remain open questions.

In addressing the issue of the artist's condition, sampling and research design may appear to be dry, technical exercises, but they are absolutely necessary. The effectiveness of any effort that minimizes the importance of such studies will be commensurately reduced; witness the limited conclusions we are able to draw from the surveys of artists that have already been conducted. The arts are too important in our society; they deserve better. Unless information is gathered more carefully, more comprehensively, we risk misallocating the precious few resources available to us.

Various arts critics in the print media claim that in each discipline we face major crises in the quality of the work. In literature, for example, it has been suggested that there is a dwindling audience (market) for serious works and fewer writers who can produce works to sustain the audience that remains.[5] In the visual arts, on the other hand, the audience (market) is increasingly sophisticated relative to the supply of top-quality work.[6] Are these opinions shared by artists? How do they affect the artist's view of his or her condition? These questions and similar ones can be answered with the aid of more systematic research.

## NOTES

1. John Robinson, Carol Keegan, Marcia Karth and Timothy Triplett, *Public Participation in the Arts: Project Report for the SPA '82.* (College Park, Maryland: Survey Research Center, University of Maryland, 1985).

2. Thomas Juster and Frank Stafford, *Time, Books and Well-Being.* (Ann Arbor, Michigan: Institute for Social Research, 1985). See also John Robinson *How Americans Use Time.* (New York: Praeger, 1977).

3. John Robinson, et al.

4. John Robinson, *Americans' Participation in the Arts: The ARTS '83-'84 Study.* (College Park, Maryland: Survey Research Center, University of Maryland, 1986).

5. Gore Vidal, remarks in the *International Herald Tribune* (March 1988).

6. Robert Hughes, "On Art and Money," *New York Review of Books,* pp. 20-27 (1987).

# THE ARTIST'S CONDITION FROM THE REGIONAL PERSPECTIVE:
## The Outlook from the Midwest

by C. Lynn Cowan

I would like to begin by telling you that the Midwest has 46,340 artists, divided almost evenly between women and men. Thirty-seven percent work in the performing arts, 63 percent in the visual arts. Their arts-derived incomes average $26,750 per year and are projected to increase at rates slightly higher than inflation for the next ten years. Eighty-two percent of these artists work full time in the arts. The 18 percent that work less than full time do so by personal choice. Eighty-eight percent are currently covered by health and disability insurance, and the average value of their IRA or Keough accounts is $32,500.

I would also like to say that these figures come from a statistically reliable, representative sample of all professional artists in the nine-state Midwest region. The data is stored at Arts Midwest, a regional arts organization located in Minneapolis, in a computer database which is fully compatible with the data collected by the other six regional organizations in the United States. I can say it, but it is not true.

Determining the artists' condition today, in the Midwest and elsewhere, depends on what those of us who talk and write about art and artists can learn about what it is like to be an artist. It is well known that compiling accurate statistical profiles of artists is no easy task. When asked, "Which *one* of the following disciplines most closely describes your work in the arts?" some artists insist on marking two or more items or casting write-in votes. Mailing addresses are obsolete before they are entered in computer databases. Who could not sympathize with the discouraged fellowship applicant confronted with a form requesting the amount of depreciation on

*C. Lynn Cowan is a Ph.D. candidate in political science at Johns Hopkins University and an information systems consultant to state arts agencies, regional arts organizations and other nonprofit organizations.*

capital equipment? And what about the artists who did not receive surveys or were too busy creating art, or waiting tables, to respond? What about those who were too angry or not angry enough or too resigned? The situation is made worse by the fact that because of limited resources, data must be collected for many purposes at once, and those who ask for the information often determine the distribution of arts programs and arts funding.

If a national arts database existed, I could order a printout and analyze it. But even so, I am not sure that statistics would answer the question of how artists are faring today in the United States. The artists I talked with warned me that there was no "state of the artist." Each artist is unique; each artist's condition varies from month to month and year to year depending on a host of influences.

However, even statistically incomparable surveys seem to yield similar results, at least those with broad demographic data, and to confirm commonly held beliefs. To determine the need for information, consulting and workshops, United Arts, a Twin Cities arts service organization, surveyed over 5,000 artists and arts organizations in late 1986. The survey covered the nine-state Arts Midwest region: Ohio, Illinois, Indiana, Iowa, North Dakota, South Dakota, Michigan, Minnesota, Wisconsin. Six hundred seventy-seven artists returned surveys. That same year, the Research Center for Arts and Culture at Columbia University surveyed visual artist applicants to the New York Foundation for the Arts' 1986 fellowship programs as well as those performing artists on its Artists-in-Residence roster.[1]

The samples were roughly comparable by gender and age. The Research Center respondents were evenly divided between women and men, with an average age of thirty-eight. Fifty-five percent of the United Arts respondents were women, 44 percent were men; 67 percent were between the ages of twenty-five and forty-five, with 37 percent between thirty-six and forty-five years of age. Respondents from both studies were primarily visual artists.

The findings confirm those of other studies: artists have lower incomes than expected for their high levels of education. The Research Center study indicated that 95 percent of the respondents had some college education and 59 percent had some graduate study. The United Arts study found that 18.5 percent had some college, 29.8 percent had a college degree, and 41.1 percent had an advanced degree. Income levels were somewhat lower in the Midwest than in New York.

| TABLE 2: Artist's Income Levels in the Midwest and New York | | |
|---|---|---|
| Income | Midwest | New York |
| $0 - 9,999 | 28% | 20% |
| $10,000 - 29,999 | 47% | 56% |
| $30,000 - 39,999 | 11% | 11% |
| $40,000 | 8% | 12% |
| no response/unknown | 6% | 1% |

How are artists different from other highly educated professionals? The primary distinction is that artists want to earn a living creating art on their own terms, while other professionals are content to work for someone else. Professional training in the fine arts does not result in offers from major corporations during senior year in college. Nor does it lead to a career track, a steady salary and benefits. Like physicists, economists, lawyers and other professionals who turn their backs on corporate life, a noncommercial artist who wants to earn a living producing art must not only create art but also create a market and methods of production and delivery for that art.

An artist is a one-person small business, an entrepreneur. Performing artists must market their skills, visual artists their products. Artists require help with management, credit, taxes, accounting, legal matters and start-up capital. They also need to locate space in which to work and to provide for contingencies if they cannot work. Yet, unlike students in business school, artists are not taught how to manage themselves as a small business.[2] One dealer observed, "Being an artist is a career. It's a job. Most people know how their professions work well beyond the specific tasks they do themselves. But artists seem to have an enormous ability not to get a handle on much outside their own studios and immediate friends."[3]

Artists face these conditions no matter where they live. Michael Braun, former programs director of Arts Midwest and current executive director of the Mid Atlantic Arts Foundation—a regional arts agency that includes New York—was surprised to find the needs of emerging artists and organizations very much the same as those in the Midwest. As it is with the homeless in Beverly Hills, the many who need help are overlooked as attention is focused on the wildly successful few.

Like the federal government's Small Business Administration and myriad state and local economic development offices, service organizations exist to help artists develop the non-arts expertise they need. However, one study in New York suggests that the "field contains so many organizations vying for a place in the service marketplace that individuals are confused

about which organizations offer what services."[4] An organization serving artists may have difficulty reaching its constituency. During a hearing held by Arts Midwest in Marshall, Minnesota, Sam Grabarski, executive director of the Minnesota State Arts Board, explained special efforts to increase participation in the Artist-in-Education program by artists in outlying areas: "We are trying to identify rural artists and encourage them to apply. If they don't apply, we can't fund them." Artist organizations serving nonmetropolitan areas confront factors of distance, travel time and expense.

Some artists direct their creativity toward the bureaucracy as well. They can be very innovative when it comes to taking care of their needs, discovering ways to make the system work for them in terms of health insurance, credit cards and bank loans. In many cases they are not only conscious of how society perceives them, but they are working to turn the system around to meet their needs. One need only think of the unemployment insurance system in this country and its hidden potential for artist subsidy to understand the point.[5]

Producing art is a labor-intensive process, but some artists are taking advantage of technological advances to increase their productivity. Bonnie Meltzer, an artist living in Portland, Oregon, uses a computer for both creating art and handling administrative tasks.

> I don't have any other tool that is both an art tool and a traditional business tool. Not only can I prepare beautifully drawn proposals and exciting computer generated collages, but I can easily maintain client files, make mailing labels, prepare letters and do my accounting. . . . Surviving as an artist is as much a numbers game as it is a creative pursuit. Artists must keep applying for commissions, grants and teaching jobs. The competition is fierce and the applicants numerous. I always joke that a computer makes it possible for me to be rejected from four times as many projects in only half the time. The important point is that, since I have been using my computer, I have also been selected to do twice as many projects.[6]

On the other hand, some artists feel powerless when confronted with bureaucratic procedures or politics. I spoke with an artist in Des Moines while he marbleized the walls of a new restaurant. He complained that the commissions awarded by the arts council always went to the same people. When I suggested that he could write to the council for an explanation, contact a council member he knew or volunteer to serve on a panel, he replied that he neither had the time nor the belief that it would make a difference.

Artists between the coasts, the so-called regional artists, face the same

problems, but with market conditions different from those in the mainstream art world. They also perceive that the mainstream art world sees them differently than they see themselves. The spring 1987 issue of the National Endowment for the Arts' *Artsreview* [7] contained interviews with artists, dealers, critics and collectors, primarily from New York. The consensus among those interviewed was that artists can produce good art anywhere, but the reality of the business is that art is shown and bought in New York. Others in the book mentioned the vitality of the artist community there. Michael Brenson, a critic for the *New York Times*, said:

> I don't think you have that same sense in a smaller city of art being something worth living and dying for — or that the issues within it are fundamental. People here feel that the stakes are very high. . . . When artists do their work, when critics write about it, they're also fighting for a way of seeing the world. . . . I don't know if that fight can possibly be the same in a place where all those issues are not as urgent as they are in New York. [8]

As Brenson says, arts criticism and review is very important to the artist and the work, but critics also function as audience educators. Ingrid Sischy, former editor of *Artforum,* noted:

> There is a particular problem in those places where artists are working almost alone in a tiny community. In those places, there are very few ways one can know about someone's work if there aren't people to tell you about it, writers to describe it. [9]

Lynne Sowder, curator and director of visual arts for the First Bank Systems in Minneapolis, described the impact of the Center for Arts Criticism: "The Center finances workshops wherein national critics work with local critics. It is inspiring a different kind of sensibility and response to work being made here and to the work being presented by the museums here." [10] She also noted that her company is the "largest supporter of the regional arts scene" but adds that "regional art comprises a small percentage of our larger collection," an emphasis shared by other regional museums.

Regional artists have fewer opportunities to sell their works due to the prevailing attitudes of regional museums toward their own artists. Hilton Kramer, editor of the *New Criterion,* explained it this way:

> The great problem of museums collecting the work of living artists today, particularly young living artists, is that the curatorial staffs of these museums have a completely bandwagon mentality. . . . You very rarely find a curator either willing or able or permitted by his superiors to act with independent judgment. The last thing you would expect is to walk

into a museum somewhere in the country and see two or three paintings by an artist you never heard of. [11]

The February 1987 *Art Link Letter,* the Arts Midwest in-house newsletter, reprinted "Viewpoint of a Regional Artist" from the Women's Artist Registry of Minnesota (WARM) Journal. It contained remarks made by Leila Daw, an installation, performance and book artist and teacher at Southern Illinois University, at a panel called "Angry" at the College Arts Association of America Annual Conference:

> I don't claim to speak for all regional artists — in fact I know I don't because a lot of us are still hesitant to identify ourselves and our problems. We all want to be universal, not regional. . . . Yet, the current situation with regard to artists who are neither "East Coast" nor "West Coast" — in other words, "regional" artists — is that we face a geographic prejudice and a set of attitudes that is just as real and also just as unconscious as gender prejudice or race prejudice. . . . Many regional artists are unable to believe in their own or each other's validity; it's hard to when nobody else does. We don't support each other, we hesitate to identify ourselves as regional, and we are so busy trying to prove we're "mainstream," whatever that is, that we don't see that there might be strength in being outside all of that.

Daw cited the following examples of problems faced by regional artists:

- A midcareer regional artist has been working with a certain set of concerns, in a certain style, for years. This artist was recently told by a regional dealer that her work is derivative of that of a young, hot New York artist whose work she has never seen. Implicit attitude: all ideas emanate from New York, or at least the coasts, and are gradually picked up and copied by those in the hinterlands.

- Originality is supposedly valued in art, yet the work of many regional artists is rejected as being too insular, too hermetic. Implicit attitude: work that has a different "look" from the prevailing trends is original if done in New York but hopelessly out of it if done somewhere else.

- A corollary to that assumption is that if you don't live in New York, you haven't made the necessary career commitment to have your work taken seriously.

- Major purchases by regional museums happen only when the art, or at least the artist, has been blessed by the nonregional media. After all, you can't have people thinking that the regional museum is provincial.

- Visiting artists programs in most noncoastal universities, arts schools

and, yes, alternative institutions consistently include a dispropor-
tionate number of coastal artists. After all, if you can afford it, you
get the best.

— Our own arts agencies give all the big commissions to the
"mainstream" artists. . . . First, they don't want to be divisive by
encouraging artists who know each other to compete for the same
commission. Second, they want to give us poor backwater artists a
treat by showing us what real art looks like.

Daw also suggested that how-tos are written from the perspective of
coastal artists. She asked, "Does it ever occur to anyone that some problems
might be qualitatively different, brought on by lower population densities,
for example?"

Some people feel that New York's monopoly on the arts world is dimin-
ishing. Dodie Kazanjian, editor of *Artsreview,* summarized the view that
"though an artist must show in New York, he doesn't have to live there be-
cause of the explosion of art all over the country—the proliferation and
strengthening of museums, contemporary art centers, and artists' spaces."[12]
David Ross, director of the Institute of Contemporary Art in Boston, com-
mented, "Once you've established those connections [to New York], it's far
better to place yourself in a situation where you can work a little less distrac-
tedly than you can in New York." [13] Gracie Mansion, a New York dealer,
gave her opinion:

Many times I hear artists say, "Maybe I should move to Chicago or
California . . . New York should smarten up and set aside more places
like Westbeth for artists so that artists will stay here. . . . For an artist to
rent a studio in California, I've heard you can get 2,000 to 3,000 feet for
$400 a month. To rent the same space in Manhattan would be between
$3,000 to $5,000 a month. . . .[14]

Marcia Tucker, director of the New Museum of Contemporary Art in
New York, pointed out the essence of the regional artists' dilemma:

Being in New York is as important as the artist thinks it is. If an artist
feels it is essential to work in New York, then she or he should come and
work in New York. But some of the most interesting artists working
today don't feel that way. If I heard that somebody really great was work-
ing in the middle of Utah, the next time one of our curators was going to
lecture in that area, that person would try to visit.[15]

There is a certain wisdom in artist Walter Robinson's advice to other
artists:

Don't come to New York. Take a vow of poverty and never sell your work. Never show it in a museum. . . . So, tell your artist readers not to worry about the art world or getting shows or anything like that. They should just do their work and when the art world wants them, it'll come and get them. [16]

Perhaps it is time for regional artists to have confidence in their own work, to appreciate the benefits of living outside New York, and time for them to stop seeking, much less depending, on validation from the New York art world. Maybe it is time for them to develop their own hype, their own aesthetic, their own mystique, time for them to be discovered by collectors and dealers. Marc Pally, an artist from Los Angeles, gave his assessment:

We need to break the tyranny of New York in terms of support. I don't know how we do that. We're off to a good start here in Los Angeles now that we have these museums. Now we need the press to follow, and we need Los Angeles collectors and New York collectors to look harder at what local talent we have. [17]

Sarah Lutman, executive director of the Fleishhacker Foundation in San Francisco, says, "It takes a special kind of artist who is able to develop a regional voice and stay in his region and contribute to it. It's one of my great sorrows that we continue to lose our mature artists to larger metropolitan areas." Appropriately enough, the seven regional arts agencies are addressing the question of how to break the tyranny of the New York arts world and provide opportunities for artists to succeed where they live. Rather than addressing the artist's condition, former *Artforum* editor Ingrid Sischy said, "What one can address in a practical way is the conditions around art." [18]

The Arts Midwest Advisory Panels for Performing Arts, Visual Arts, Jazz, the Arts in Smaller Communities and the Arts in Minority Communities met in 1986 and 1987 to identify trends and issues to guide policy development. Among the general needs discussed were:

– Audience education

– Support mechanisms for minority and traditional artists

– Better understanding of traditional art forms

– Affordable workspace, due to gentrification of artist communities

– Better management, marketing and promotion skills for artists

– The need to include artists in decision making

- More realistic artist expectations
- Increased access to corporate and foundation support
- The need for artists to be paid for their work
- Alternatives to the dominance of elitist, white, male, European traditions
- Definition of the Midwestern aesthetic
- High-quality arts criticism
- Funding, not only for conservative and established artists but also for risk-taking, emerging and innovative artists
- Higher national profiles for regional arts institutions

The Visual Arts panel members were concerned about the stigma attached to programs that focus on regional or local artists and the prevailing notion that Midwest artists are somehow second-class citizens in the art world. Organizations are often reluctant to present exhibitions of works by regional artists because such shows may not draw large audiences. Both the organization and individual artist panels agreed that regional artists need exposure, not just where they live but in other areas of the country as well.

The Arts Midwest application to the National Endowment for the Arts for a Visual Arts Program Special Projects Grant gave an appraisal of the current artistic climate:

> Visual artists choosing to live in the Midwest have fewer opportunities for encouragement, recognition, and financial support. Many tend to feel isolated from artistic activity and from each other. . . . There has been a migration of artists away from the Midwest. A study of artists published in March 1987 by the National Endowment for the Arts indicates that our region of the country has lost more artists than any other region over the five-year period researched. . . . Arts Midwest believes that artists do not have to live in New York to succeed in their profession; although that city may boast an active artistic climate, it should not be the only place for artists to successfully create and market their works. Corporations may need to be listed on the New York Stock Exchange, but they can be headquartered anywhere in the country. In much the same way, artists may at some point need promotion in the New York art world, but they should be allowed to live and work anywhere (July 10, 1987).

The traditional means of assisting individual artists has been through fellowships and technical assistance in marketing, accounting and so on. Fellowships provide meager financial support but they are valuable because

they bestow recognition and validation and help artists get work, tenure and other grants. Funding will never be sufficient to grant fellowships to all the artists who deserve them. Rather than concentrating on direct benefits, regional organizations are gradually complementing their efforts in direct artist support with efforts to improve the market for the arts within their region and elsewhere.

In 1987, to coincide with an exhibition of its 1986-1987 fellowship winners, "Choices: Twenty Painters from the Midwest," Arts Midwest sponsored a symposium titled, "Collecting Contemporary Art in the Midwest." It featured a keynote address by Grace Glueck, art critic for the *New York Times*, and both corporate and private collectors participated, as well as galleries and museums. That same year, the Minnesota State Arts Board and Arts Midwest brought the American Craft Enterprise Craft Fair to St. Paul. It produced sales of more than $1.5 million with an attendance record that exceeded all other first-time shows. [19]

Beginning in 1988, Arts Midwest received funding for a Dakota Field Representative. This representative will travel throughout the Dakotas for two years, seeking to determine and address the arts needs of rural areas. In spring 1988, Arts Midwest sponsored a series of retreats to deal with the topic of stimulating new work. Their goal was to develop a dialogue between culturally diverse artists, dealers, arts organizations, grantmakers and representatives of artist's spaces. These special programs complement the organization's fifteen-year regional performing arts touring program and visual arts programming efforts. In addition, Arts Midwest has a substantial database of performing arts presenters, jazz performers, educators and resources. They recently developed a visual arts database that provides such information as sponsors of artist competitions, slide registries and which media various organizations present.

Regional arts organizations provide exposure for their artists since they invite respected people in the arts who are based outside the region to serve as fellowship panelists or to curate exhibits. This practice prevents conflict of interest and, at the same time, shows outsiders what regional artists have to offer. Most regional organizations now seek out private-sector directors for their boards. Soliciting board members from outside their region, as Western States Arts Foundation already does, would provide a more lasting line of communication to the mainstream art world.

While this paper focuses on the Midwest, other regional arts organizations are engaged in similar activities. Some have suggested they join forces, for example, by establishing a gallery in New York similar to the one operated by the Canada Arts Council, or by publishing a joint catalogue of fel-

lowship winners. States court businesses to relocate within their borders. Regions, states or communities with active, growing artist populations might publicize the "quality of life" advantages to living in their area, rather than in New York, with the intent of drawing artists there along with the galleries and collectors that presumably would follow. Regional arts organizations have as their priority retaining and supporting artists in their areas. Artists, working with such organizations, can shape a regional environment conducive to high-quality art and a high quality of life for artists.

## NOTES

The author would like to thank David Fraher and Jeanne Lakso of Arts Midwest, Phil Docken, and David Keen for their assistance in preparing this paper.

1. Joan Jeffri, Joseph Hosi, Robert Greenblatt, "The Artist Alone: Work-Related, Human, and Social Service Needs – Selected Findings," *Journal of Arts Management and Law* 17 (Fall 1987).

2. Mariann Johnson, United Arts, St. Paul, Minnesota, quoted in *Twin Cities Reader* 13 (February 10-16, 1988).

3. Helene Winer, Dealer, Metro Pictures, New York City, quoted in "Portrait of the Artist, 1987: Who Supports Him/Her?" *Artsreview* 4 (Spring 1987), p. 83.

4. Joan Jeffri, et al., op. cit.

5. Ibid.

6. Bonnie Meltzer, "Computers Should Be Seen as Artist's Tools, Rather than Enemies of the Arts," *PC Week* 4 (February 9, 1988), p. 33.

7. National Endowment for the Arts. *Artsreview* , Portrait of the Artist : Who Supports Him/Her? Washington, D.C. : National Endowment for the Arts, spring 1987.

8. Ibid., p. 27.

9. Ibid., p. 39.

10. Ibid., p. 86.

11. Ibid., p. 78.

12. Ibid., p. 5.

13. Ibid., p. 97.

**15.** Ibid., p. 102.

**16.** Ibid., p. 106.

**17.** Ibid., p. 90.

**18.** Ibid., p. 37.

**19.** *Art Link Letter* 3 (November 1987), p. 7.

# FORECASTING ARTIST EMPLOYMENT TO THE YEAR 2000

**by Tom Bradshaw**

Two factors are critical in forecasting occupational employment. The first is supply. How fast will the labor force grow between now and the year 2000? The answer, in brief, is slowly. In fact, the percentage increase in the labor force from 1986 to the year 2000 is expected to be only 18 percent, as compared to a 35-percent increase over the last fourteen years. The reason for this is that the baby-boom generation is now in the labor force. But from now until the end of the century, the "baby dearth" generation will be entering the labor force, resulting in slower growth.

The second critical factor in forecasting is the projected growth of the major industries providing employment for an occupation. The situation for individual artist occupations varies substantially, since they are employed by such a wide variety of industries. For example, the number of employed actors, directors and producers will show large increases because the theater and motion picture industry will grow rapidly. On the other hand, the radio and TV broadcasting industry is not predicted to grow as fast as the other artist employing industries, so there will be slower growth in the number of radio and TV announcers employed.

Before discussing specific growth projections for artist occupations, I would like to give some background on the two data systems I will be using and review the growth in artist occupations over the last decade and a half. The first source is the federal government's Census of Population. It is the largest of the data systems and involves the collection of substantial demographic information on the population as a whole. Occupational information is collected on the long-form questionnaire, which in 1970 was distributed to 20 percent of the population, and in 1980 to about 17 percent. The advantage of these statistics is that the census sample, although not 100 per-

---

*Tom Bradshaw is the acting director of the Research Division, National Endowment for the Arts.*

cent, is extremely large and provides nationally representative occupational statistics. Through the census, a variety of detailed characteristics, such as age, sex and earnings, can be examined for artist occupations and compared to those of other occupations.

The second source is the Current Population Survey, a general population survey of about 60,000 households conducted monthly by the Bureau of Census for the Bureau of Labor Statistics, which serves as the source of national employment and unemployment statistics. While the sample size of this survey is not equal to that of the census, it is one of the largest sample surveys in the world. The Current Population Survey uses the same occupation questions as the decennial census, making comparisons between the data sets possible.

What do these sources show us about the growth of artist occupations in recent years? As you can see from Table 1, the artist labor force as a whole

**TABLE 1 : Artist Labor Force, 1970 and 1980**

|  | 1970 | 1980 | Percent Change |
|---|---|---|---|
| **Total U.S. Labor Force** | 79, 801,605 | 104,057,985 | 30 |
| **Professional Speciality Occupations** | 8,800,210 | 12,275,140 | 40 |
| **All Artists** | 736,960 | 1,085,693 | 47 |
| Actors/Directors | 40,201 | 67,180 | 67 |
| Announcers | 25,942 | 46,986 | 81 |
| Architects | 53,670 | 107,693 | 101 |
| Authors | 27,752 | 45,748 | 65 |
| Dancers | 7,404 | 13,194 | 78 |
| Designers | 232,890 | 338,374 | 45 |
| Musicians/Composers | 99,533 | 140,556 | 41 |
| Painters/Sculptors/ Artist Printmakers | 86,849 | 153,162 | 76 |
| Photographers | 67,588 | 94,762 | 40 |
| Teachers of Arts, Drama, and Music (Higher Educ.) | 42,000 | 28,385* | - 32 |
| Other Artists, N.E.C. | 53,131 | 49,653 | - 7 |

Source: 1970 and 1980 Census of Population.

*The number of postsecondary Teachers of Art, Drama, and Music in 1980 is substantially underestimated because two-thirds of the postsecondary teachers in the 1980 census did not specify a subject area—only 29 percent failed to do so in the 1970 Census.

grew more rapidly in the decade of the seventies than did either the overall U.S. labor force or professional speciality occupations. For artists, the aggregate percentage increase was 47 percent, compared with 30 percent for the overall labor force and 40 percent for professional speciality occupations. If we look at the individual occupations, we see that the largest increases were among architects, announcers, dancers, and painters and sculptors. The only declines are seen in the category "other" — a catchall category for artists not classified elsewhere — and among teachers of art, drama and music. However, as the footnote indicates, there is evidence that the number of teachers of art, drama and music reported in 1980 may be too low. Other occupations with below-average increases included musicians/composers and photographers.

The most recent data from the Current Population Survey (CPS) are shown in Table 2. Because a new occupational classification system was introduced in the CPS in 1983, the data start in that year, rather than in 1980 or 1981, and continue through 1987. The same new system was introduced in the 1980 census, and the 1970 census occupation estimates were sub-

### Table 2: Artist Labor Force, 1983 and 1987

|  | 1983 | 1987 | Percent Change |
|---|---|---|---|
| **Total U.S. Labor Force** | 111,550,000 | 119,865,000 | 8 |
| **Professional Speciality Occupations** | 13,219,000 | 14,726,000 | 11 |
| **All Artists** | 1,301,000 | 1,558,000 | 20 |
| Actors/Directors | 71,000 | 98,000 | 38 |
| Announcers | 41,000 | 62,000 | 51 |
| Architects | 108,000 | 136,000 | 26 |
| Authors | 64,000 | 86,000 | 34 |
| Dancers | 12,000 | 16,000 | 33 |
| Designers | 415,000 | 546,000 | 32 |
| Musicians/Composers | 170,000 | 177,000 | 4 |
| Painters/Sculptors/ Artist Printmakers | 192,000 | 198,000 | 3 |
| Photographers | 119,000 | 131,000 | 10 |
| Teachers of Arts, Drama, and Music (Higher Educ.) | 43,000 | 41,000 | -5 |
| Other Artists, N.E.C. | 66,000 | 67,000 | 2 |

Source: Bureau of Labor Statistics' Current Population Survey

sequently adjusted by the Census Bureau to reflect the new classifications. So 1983 was the first year that CPS categories were identical to the 1980 census. As was the case in the 1970s, the increase for artist occupations as a whole was larger than that for professional speciality occupations or the total civilian labor force. Overall, the labor force for artist occupations increased approximately 20 percent; professional speciality occupations increased 11 percent, while the total civilian labor force increased 8 percent. Looking at the individual occupations, we see the greatest increase among announcers and large increases among actors/directors, authors, dancers, designers and architects. Another trend that began in the 1970s and continued in the 1980s was very slow growth among musicians and composers and some decline among teachers of art, drama and music. In contrast to the 1970s, we see smaller increases among painters and sculptors in the current decade. After a slightly below-average increase in the prior decade, designers showed a substantial increase. This suggests that some shifting toward design occupations and away from painter/sculptor occupations may be occurring.

Now the question arises: Will the rapid growth that took place in artist occupations in the seventies and the first half of the eighties continue to the end of the century? Before answering that question, a brief explanation of how the Bureau of Labor Statistics develops its projections is in order. Five models are used to produce occupational projections. The first model makes use of the Decennial Census of Population, the Current Population Survey, and the Chase Macro Economic Model in projecting the size of the future labor force. The second step in the process uses the projected size of the future labor force along with assumptions about economic activity to estimate such macroeconomic variables as unemployment, inflation and the various components of the gross national product (GNP) that represent aggregate final demand for goods and services. In the third step, using an industry activity model, final demand for goods and services is distributed across various industries of the U.S. by means of a bridge table, or a set of percentage distributions of aggregate final demand among industries. In the fourth step, an input/output table is used to add intermediate demand to the final demand that was distributed in step three. The fifth step uses an industry labor demand model to forecast future employment for each industry based on the projected total demand for that industry's output. An occupational labor demand model is used in the last step to transform the result of the previous step into employment forecasts for individual occupations, such as artist occupations.

These projections, shown in Table 3, are made in terms of employment levels, not labor force levels as in Tables 1 and 2. Also, the artist occupa-

### Table 3: Projected Employment in Artist Occupations to 2000
### Total employment, in thousands, projected to 2000
### (Projected percent change)

| Occupation | Base Year of 1986 | Low Trend | Moderate Trend | High Trend |
|---|---|---|---|---|
| Actors, directors, producers | 73 | 87 (20) | 97 (34) | 103 (41) |
| Architects, except landscape and Marine | 84 | 102 (22) | 108 (30) | 112 (34) |
| Dancers and choreographers | 14 | 17 (24) | 18 (31) | 19 (34) |
| Designers (except interior) | 259 | 322 (24) | 343 (32) | 357 (38) |
| Musicians | 189 | 218 (16) | 231 (23) | 239 (27) |
| Artists, Commercial artists | 176 | 218 (24) | 235 (34) | 246 (40) |
| Photographers, camera operators | 109 | 137 (25) | 146 (33) | 153 (41) |
| Radio/TV announcers and newscasters | 61 | 71 (16) | 76 (24) | 84 (38) |
| Writers and Editors | 214 | 268 (25) | 287 (34) | 301 (41) |

Source: Bureau of Labor Statistics' Division of Occupational Outlook

tions used here are not identical to the occupations listed in the CPS or the Census because they come from the Occupational Employment Survey (OES). The OES is a periodic mail survey conducted by state employment agencies of a sample of employing establishments to obtain wage and salary employment by occupation. The results are used to estimate how industry employment is distributed by occupation nationally and by state. By combining the results of this survey with those from the CPS, the bureau is able to construct a national industry-occupation matrix. Although most of the occupations shown in Table 3 are substantially the same as those in Table 1 and 3, there are differences. Authors are not shown separately but are included in the broader group of writers and editors, and the category of designers does not include interior designers in Table 3.

What are the projections for the artist occupations? Employment levels for individual artist occupations are shown in Table 3. The year 1986 is used as a base, and projections are given at low, moderate and high levels to the year 2000, with the corresponding percentage increases shown in the final three columns. All artist occupations will experience significant growth to the year 2000, according to these projections. Looking at moderate-level projections, increases range from 23 to 34 percent. The largest increases are projected for actors and directors, artists and commercial artists, and writers and editors. The lowest projected increases are for musicians and

**Table 4: Employment Projections, 1986 to 2000**

| | 1986 | 2000 | Percent 1972 to 1986 | Change 1986 to 2000 |
|---|---|---|---|---|
| Total Civilian Employment | 111,623,000 | 133,030,000 | 33 | 19 |
| Professional Workers | 13,538,000 | 17,192,000 | 58 | 27 |
| Artists | 1,179,000 | 1,541,000 | 84 | 31 |

Source: Bureau of Labor Statistics' Division of Occupational Outlook

radio and television announcers.

Table 4 compares the increases in artist occupations as a whole with those for all professional workers and for total civilian employment. Artist occupations are projected to increase more rapidly than either of the other two groups. Further, each individual artist occupation will increase at a rate greater than the average for all civilian workers and, with the exception of musicians and radio/TV announcers, at a rate higher than for all professional workers. However, for all three groups — total civilian workers, all professional workers and artists — the increase is expected to be substantially less in the next fourteen years than it was in the previous fourteen. This is explained in part by the slower labor force growth projected from now until the end of the century.

For the purpose of projecting growth of the major industries that employ artists, the Bureau of Labor Statistics separated artist employment into two categories: wage and salary employment and self-employment. The wage and salary category is larger and is projected for each industry that employs artists, using current levels of employment and forecast growth (based on the economic models described earlier). Table 5 shows employment by the major industries in 1986 and projected levels for the year 2000. Looking at the artist occupation actors/directors/producers, we see that the motion picture and theater industries are responsible for the majority of wage and salary employment for this occupation. It is interesting that over the next fourteen years the theater industry is projected to increase more rapidly than the motion picture industry. The occupational category "artists &commercial artists" shows the greatest employment increases in the advertising industry and the next greatest increase in the commercial art industry. For architects, the increase is projected mostly for those employed in individual architectural firms. For dancers and choreographers, restaurant and night club employment is projected to increase at the fastest pace, followed by theatrical dance. The greatest increase for designers is expected to occur in individual architectural firms, with a decline projected in the number

## Table 5: Industry Employment Projections for Artist Occupations, 1986 to 2000: Wage and Salary Employment

| | 1986 (000s) | 2000 (000s) | Percent Change |
|---|---|---|---|
| **Actors/Directors/Producers** | 54.6 | 73.5 | 35 |
| Theater Industry | 15.2 | 21.1 | 39 |
| Motion Picture Industry | 27.8 | 36.7 | 33 |
| Radio & TV Broadcasting | 7.7 | 10.1 | 31 |
| **Artists & Commercial Artists** | 65.6 | 89.5 | 36 |
| Advertising Industry | 16.1 | 24.6 | 52 |
| Commercial Art Industry | 11.9 | 16.4 | 38 |
| Printing & Publishing | 12.7 | 14.4 | 14 |
| **Architects, except landscape and marine** | 53.6 | 69.3 | 29 |
| Architectural & Design Firms | 46.8 | 60.6 | 29 |
| **Dancers and Choreographers** | 11.9 | 15.3 | 31 |
| Restaurants & Nightclubs | 2.3 | 3.3 | 42 |
| Theatrical Dance | 4.3 | 5.8 | 33 |
| **Designers** | 160.4 | 210.3 | 31 |
| Advertising Industry | 9.0 | 14.2 | 58 |
| Commercial Art Industry | 6.7 | 10.6 | 58 |
| Architectural & Design Firms | 12.1 | 18.8 | 52 |
| Retail Trade | 64.3 | 83.6 | 30 |
| Manufacturing | 35.6 | 34.7 | - 3 |
| **Musicians** | 119.6 | 143.1 | 28 |
| Restaurants & Nightclubs | 7.5 | 11.0 | 46 |
| Bands & Orchestras | 42.0 | 58.3 | 39 |
| Religious Organizations | 55.2 | 52.9 | - 4 |
| **Photographers & Camera Operators** | 59.2 | 80.7 | 36 |
| Commercial Art Industry | 7.9 | 12.2 | 53 |
| Photographic Studies | 17.7 | 25.6 | 44 |
| Motion Picture Industry | 3.3 | 4.6 | 37 |
| Radio/TV Broadcasting | 9.3 | 12.4 | 33 |
| **Radio/TV Announcers/ Newscasters** | 55.9 | 69.4 | 24 |
| Theater Industry | 3.0 | 4.0 | 31 |
| Radio/TV Broadcasting | 51.4 | 63.4 | 23 |
| **Writers and Editors** | 144.7 | 193.9 | 34 |
| Computer/data processing services | 5.9 | 2.2 | 106 |
| Advertising | 9.3 | 15.4 | 65 |
| Radio/TV Broadcasting | 6.7 | 9.2 | 37 |
| Painting & Publishing | 58.3 | 74.2 | 27 |

Source: Bureau of Labor Statistics' Division of Occupational Outlook

employed in manufacturing. For musicians, the greatest increases are in the restaurant and night club industry, followed by bands and orchestras. There were a substantial number employed by religious organizations in 1986, but a decline is projected in the next fourteen years. For photographers, the greatest increases are anticipated in the commercial art industry and portrait studios, and a fairly large increase is projected in radio and TV broadcasting. Announcers will see the greatest percentage increase in the theater industry. Of course, radio and TV broadcasting will still be the industry in which most are employed. Finally, among writers and editors the largest increases will be in computer and data processing services, although substantial increases in the advertising industry will occur as well.

In conclusion, because the industries in which most artists are employed are expected to grow at above-average rates to the year 2000, employment in artist occupations is expected to grow at above average rates during that time as well. Projected growth in individual artist occupations varies to the extent that the occupation is or is not a part of the more rapidly growing industry sectors. However, growth in artist occupations is not expected to be as great in the next fourteen years as it was in the last fourteen years, reflecting a similar situation for all civilian workers and all professional workers. Overall, as it has for the last decade and a half, growth in artist occupations is expected to continue at a pace more rapid than that of all professional workers or the total civilian labor force.

# THE ARTIST'S CONDITION:
## Comment and Discussion

## BRANN J. WRY

A recent Harris survey indicates an upgrade in the attitude of the American public toward working artists. Forty-six percent of those surveyed felt that our artists should receive funding from the government and from other sources. Additionally, those polled consider artists to be engaged in a worthy profession which people may pursue one way or another and still be considered working members of the community. In a *New York Times* article about the survey, the author says, "The survey, for the first time, examined public attitudes toward artists and found surprisingly widespread admiration. Majorities rejected stereotypes of artists as undisciplined, unfocused, or unable to do an honest day's work. And 84 percent agreed that artists are highly important to the life of this country."

A more recent article in the business section of the *Times* indicated that art is increasingly newsworthy in a business context. The article talked about the works on display at the midtown-Manhattan International Center of Photography that showed the commercial uses of art — applied art which was also being considered and classified as fine art. The author Lawrence James points out that, while commercial art used for advertising purposes previously was simply thrown away, today much of it is being conserved and shown to the public.

In her presentation, Lynn Cowan mentioned Sam Grabarski, the executive director of the Minnesota State Arts Board, talking about trying to find artists in the rural setting and getting them to apply for support to the agencies that could affect their future. This is a big problem for those Midwestern artists and for others classified as regional artists. I remember an economics professor at UCLA, Michael Branfield, a man who grew up in Chicago, describing why there were so many Midwesterners teaching at

UCLA. He said when you stand in Chicago, there's a big rainbow that goes right over the city. On one side of the rainbow is New York, and there is a pot of gold over there. On the other side of the rainbow is California, and there is a pot of gold over there. That is an unfortunate model that we Americans perpetuate.

I think it is tragic that someone would talk about an artist as a "regional artist." Nobody has ever walked up to me and said, "Hi, I'm a regional artist," even though I have represented artists who may have that nomenclature in the business. I do agree with Lela Daws, who was quoted by Lynn Cowan: "We all want to be universal, not regional artists."

Some of the findings cited by Lynn Cowan are in an article by Joan Jeffri, Joseph Posey and Robert Greenblatt in the *Journal of Arts Management and Law*. What they are talking about is the artist alone, the work-related human and social services needs. They refer to Michael Harrington's book, *The Other America,* in which artists are characterized as, "Oh, artists, the different poor." We live with that. We've heard it in the statistics today. We know it as part of reality for many artists.

Some of this poverty, according to Harrington, is "because the artist has chosen a way of life, instead of being victimized by it, and is fleeing a spiritual poverty in the affluent society. This flight is perhaps not so much a desire to be poor as a desire to live by a different value system, which becomes more and more apparent with the growth of consumerism in America."

At the same time, I know that as artists become more professional, as they begin to make a living in the mainstream of American society, they face some very hard realities. One of the hardest is the tax code. Douglas Bell, in a *Journal of Arts Management and Law* article, talks about the possibility of changing our present code so that artists may once again deduct the fair market value of their works if they give them to a nonprofit institution. They have not been able to do that for twenty years.

The tax code is a double-edged sword in this regard. If an artist gets to the point where the works are worth something and carry an inventory value at his or her death, even though the artist was never able to deduct the fair market value, the heirs are taxed on the full market value of the works in the estate. So all of a sudden the entire inventory assumes this marvelous value that it never had during the artist's lifetime. Bell argues that "the change, therefore, must take place in our income tax laws in order to allow artists to deduct fair market value for the donation of their self-created works. If critics strongly object to the concept of letting artists take the

deduction for their services, a viable alternative exists whereby an artist would be permitted to pay taxes based on the personal service portion of his work immediately after completion of a creation. Any appreciation in the value of the artwork after this time would be capital gain and thus entitled to a fair market deduction upon donation to a qualified museum."

The environment for all artists is increasingly complex and, for those artists not in California or New York, the seven regional arts organizations understand this complexity and try to address it by creating different markets and different venues for showing art. Various model programs and agencies help the artist to negotiate this environment. When artists on their own, unschooled in the vagaries and necessities of running themselves as businesses, confront the complex task of entering the marketplace — where, among other challenges, they encounter a system of tax codes that runs against their best interests — arts organizations can be of great help. But the problem is also one of a society that doesn't acknowledge art as a very important part of the culture. The Harris poll seems to suggest changes in that attitude. I hope those changes and our discussion here today will provide a better environment and some practical solutions for artists in our society.

## GEORGE KOCH

To discuss the condition of the American artist, I use a standard approach that parallels many of the things said in the presentations. I begin by dividing American society into two groups: artists and those whose education is comparable. Then I compare these two groups, and I find that American society makes five promises to the artist. First, artists will spend more time and money educating themselves while in the work force than will other workers with the same amount of education. They will spend more of their disposable income on continuing education because, throughout their life-times, they are constant learners. Second, they will be unemployed more often. Third, their unemployment will last for longer periods of time. Fourth, in their lifetimes they will work less as artists — as dancers, painters, musicians — than their counterparts will work as analysts or managers. Finally, and not surprisingly, artists will earn less in their lifetimes than their colleagues in other occupations.

When you look at these five promises, you begin to wonder what drives people to accept such conditions. In looking at the available data, we are seeking a better understanding of the condition of the artist. But one thing that concerns me is that, although we are looking for the right thing, we may not know where to look.

For example, in analyzing the data, if we use the model that society uses—the Bureau of Labor Statistics model—we find that the individual creators are dropped out of the system. There is no way the system can find them. You can find the designer in the ad agency because you can go to the agency and say, "How many designers do you have?" You don't walk into a community and say, "How many creative visual artists are there in this community?" There's no organized way of finding them. We are very good at finding things that are organized; we are very bad at counting those things that are not.

Arts researchers need to be advocates for better research. For instance, when employer-based studies are done by the Bureau of Labor Statistics, they could recommend that the bureau should be considered as a data source and arts organizations should be considered as establishments. They would use the same structure that is now being used to count employment generally, but to count artists, they would use a different and better base: the arts organization as an establishment.

The study on individual artists conducted by the New England Foundation for the Arts is one of the best I have seen, primarily because it looked at artists normally missed by surveys. The foundation's researchers started with what John Robinson referred to in his presentation as Type 2 people (artists counted as nonartists), rather than with the population overall. This is an example of how the information we already have about individuals in the system can be improved—by a different orientation on the part of people doing arts research.

I also want to mention two factors that have not been taken into account in some of the studies being presented. One is that more people in our society are taking on second careers. Normal projections of growth rates don't account for this factor. It will result in decreases in some professions and increases in others—statistical changes driven by individual decisions, not by birthrates—and yet we have no way of articulating and examining this. The second career is a new phenomenon, particularly in the arts, and we need to examine it more closely along with other kinds of things we are not looking at now. I don't know how to do it, but there are professionals who may be able to develop the techniques.

The second factor is the phenomenon of dual careers. In a sense, being a creative artist requires an individual to have a dual career. One pays the bills; the other is what the artist actually wants to do, but it doesn't produce enough income by itself. The contemporary employment market contributes to this. For example, I recently heard a radio advertisement for Kelly Girls. It was nothing more than a conversation with a woman who, as a visual art-

ist, was having her second one-person show. But what Kelly Girls was selling was the artist's word processing skills. Working as a word-processor gave her the freedom to pursue her career, she said, because she could work when she wanted, for a fairly high salary. This is only one example of a widespread phenomenon that we have overlooked in our studies and don't yet understand.

## MURIEL CANTOR

I will focus on the opportunities and difficulties in trying to use census data and Current Population Survey data to assess the economic condition of performers or to project their future employment. Obviously, the statistics from the survey of occupation employment are more useful than the data from either the Census of Population or the Current Population Surveys (CPS), but the occupation employment statistics also are far from ideal for projecting the future in artistic employment.

My study of employment and unemployment of performers, especially actors, has convinced me that we have to develop new and better data sources and strategies, as well as new conceptual frameworks that are different from what we now use. The occupational and industrial data on performers obtained from federal sources are just not adequate to establish the number of artists, the supply of artists and their availability for work.

There are a number of problems with the census and the CPS data. The first is conceptual. Above I used the word "performers," rather than the words "performing artists," and that is illustrative of the problem. We have at least three definitions for "artist," and there are probably more. The first and most commonly used definition encompasses only those individuals recognized as artists by the community. The second is a self-definition—individuals who identify themselves as artists. The third definition—the one used by the Arts Endowment—recognizes as an artist anyone working in one of the eleven related occupations defined by the Bureau of Census and the Department of Labor. Of these three definitions, the last is most problematic because of the list of the eleven occupations. Musicians, actors and dancers are all performers, and *some* are performing artists; but within that larger category, only some of the specific occupations are recognized by the community as artist occupations. Some performers are recognized as artists and others are not. However, all the national data we have on the performing arts are buried in those figures on performers in the three larger occupational categories. Striptease artists are counted with ballet dancers, for example. The category for musicians includes church singers. This is not to

suggest that church singers are not talented, but other performers work in quite different industrial contexts.

There are two things that I think are clearly wrong with the data. They are similar to the Type 1 and Type 2 errors discussed by John Robinson, but also slightly different. One, people defined as workers by the Department of Labor and the Bureau of Census are individuals who are working during the census week or the week before. This means that a number of artists are missed, not only by omission — those who do art in their spare time — but also people who might indeed be performing artists but who, because they couldn't find employment, are not working as performers at the time they are queried. Thus, the definition of employment used by the Labor and Census Bureaus results in an undercounting of the supply of artists. In fact, the census data tell us more about demand than they tell us about supply.

The formula used to define unemployment also underestimates the numbers. The Labor Bureau restricts the term *unemployment* to those who are available to work and looking for jobs; consequently, those who have given up looking for work — including artists, as they move in and out of the labor force — are not counted. Some of these difficulties arise because the work typically available to performing artists is at best part-time, seasonal or periodic. This is particularly true for actors, but it is true for others as well. For example, one-fifth of the male dancers surveyed reported that they had less than six months of work in 1969, and in 1979 the situation was practically the same. If they took other jobs between performing assignments, such as store clerk or waiter, they were counted as store clerks or waiters, not as dancers. So we have many artists who are counted as something else.

We could produce better data, and I have some suggestions, some of which are very similar to those discussed by George Koch. One thing we absolutely need is a special survey of artists, both visual and performing artists. This was done for farm workers a few years ago, and it seems to me that it would be feasible to do it for artists.

Second, when we do these employment studies, we should make them more comprehensive. Because of the way the questions are asked for the census data and the way the results are coded, much about a person's background is missed. We could do a special survey of career patterns. We could complement the federal data with data gathered from the unions, the health and welfare plans, with data available from Actors' Equity and the Screen Actors' Guild. Professional schools and trade programs could be a regular source, possibly every five years. In addition, a special sample survey of the population should be undertaken, not only to discern work and career patterns in more depth, but also to get some real data on the extent

to which age, gender and race groups move along separate career tracks and occupy different niches in the performing world.

Certain subjective judgments also might be included in future data gathering. For example, the Bureau of Labor Statistics projections do not take into account changes in public taste brought about by demographic shifts. Baby-boomers will be in their fifties in the year 2000, and the demand for the arts may be different then than it was in the 1960s.

There are also technological advances to be considered. One day I was listening to the music in a movie and realized that it was electronic. I was really surprised, because I hadn't realized that the sentimental stuff I used to hear when I was a girl had disappeared; and in its place was this modern music composed by computer. It made me realize that we have to think about the industrial and technological atmosphere in which artists work and about what that means for arts research.

Tom Bradshaw's data, as well as data from other sources, indicate that many people go from one occupation to another, especially since the industrial structure during the last twenty years has changed so dramatically toward emphasizing the service sector. It would be terrific if we could do a cohort analysis—take groups of people and follow them through their career patterns the way the public health people do on some of the data that they collect.

Finally, whatever features may differentiate artistic occupations from other professions, artists are subject to the same political, social and economic forces that govern the availability of any kind of work in the job market. Some might believe that having unique artistic talent frees artists from the constraints that ordinary people face, but artists are affected by the industry that structures the work by which they earn a living. Performing artists may be particularly dependent on these industries; movie and television actors, for example, are directly affected by changes in that industry. Thus, the puzzling relationship between employment and unemployment for all workers is probably even more perplexing when the analysis focuses on the artist.

## DISCUSSION FROM THE FLOOR

**MARIT BAKKE:** In looking at the federal figures and thinking about their effects, it seems to me that they will increase the perception of art as a commodity, and it is important to break that impression. How do we get the creative artist into the statistics?

that these are not the only sets of statistics that come from the Arts Endowment's Research Division. These are our most recent projections. Second, the Office of Management and Budget requires us to use the statistics of the Bureau of Labor Statistics on employment-unemployment information, so we do not have the prerogative to go in a different direction.

In regard to the statistics collected by the Arts Endowment, we have a number of special occupation surveys. For our survey of visual artists in four cities across the United States, we went in a totally different direction. We went to the exhibition spaces – galleries and museums – and looked for artists who had exhibited in the last three years. We asked them a lot of questions of interest to us that we cannot get through census material, questions such as: "What were you earning through your art?" "Do you have another job?" "What were you earning in that job?" Questions such as these are useful to our agency and to the Visual Arts program.

The data that I used in my presentation came from another direction; they provide a measure of the national employment-unemployment statistics and are an aggregate measure of the economy. They give us some notion of the levels of the artist population that are working as compared to other occupations. We are the first to admit that it is a limited perspective, containing both Type 1 and Type 2 errors – there's no question about that.

The 1990 census is now being planned, and a number of federal agencies have pushed to put in a second question which would ask if respondents had another job in addition to the principal job listed. Unfortunately, there is some concern that the 1990 questionnaire may be shorter – it will by no means be longer – and so that question will not be included.

I certainly concur that these data are not the ultimate measure of the artist population and certainly not the only data you would want to look at. At the Arts Endowment, we make many efforts within the Research Division to go in directions other than the census data route. We have looked at some union statistics on actors' employment. We studied craft artists using a national study that went to the crafts membership organization. I did not mean to present what I discussed earlier as *the* Arts Endowment research effort on artists. I was trying to give you an update on the most recent projections available.

**JOHN ROBINSON:** I would like to make two points. One is that if you look at the last column of the data I presented, you will see a decrease in real income between 1969 and 1979 across all occupations. For professional and technical workers there was an 8 percent decline in real income; for artist occupations, the decline was 37 percent. So while there may be more artists, the individual artist is making less money, and that's an important factor to consider. Second, I think the Endowment has done some research that takes

into account the fact that many artists have supplemental income — spouses who provide support for their activities, for example. That is another important contextual fact.

**JACK GOLODNER:** The Office of Management and Budget may have asked the Arts Endowment to use the Bureau of Labor Statistics (BLS) figures for the gross statements about employment-unemployment, but not to break it down by occupation. The BLS has told the Arts Endowment not to use the data in this fashion, but it continues to do so, understating both the number of actors and the unemployment among artists in this country. It is not correct to say that the Arts Endowment is forced to use these data. The problem is the way you are using the data, which even the Department of Labor says is wrong. The information is based on a random survey of 60,000 households. When you break it down to artists, you are dealing with about 720 individuals — which includes only fourteen dancers. The margin of error increases because the survey was never intended to be used the way you are using it.

You could use data from other sources, such as those that Muriel Cantor mentioned. There is an abundance of data — from the health and welfare plans as well as from the unions — and Research Study No. 1, "Understanding the Employment of Actors," recommended to the Arts Endowment that it take advantage of private sources. The Screen Actors Guild, Artists Equity, the Directory of Musical Arts — each of these has its own data, collected for specific purposes. They have been offered to the Endowment, but the offers have not been accepted. The only time these data were used was in the seventies — by the Department of Labor. We need to do a better job of understanding the condition of artists, and these data are one way of doing that.

# support for older artists

# SUPPORT FOR OLDER ARTISTS

## by Bruce L. Payne

> *Oedipus: I come to give you something, and the gift*
> *Is my own beaten self: no feast for the eyes;*
> *Yet in me is a more lasting grace than beauty.*
>
> — Sophocles[1]

I want to urge individuals and organizations who care about the arts to be more concerned with the problems and needs of older artists and to be more alive to the gifts that these artists have to give. My focus here will be on painters and sculptors because I know more about their work and circumstances and because the obstacles they face are in some ways different from those affecting performers, writers and composers.

Let me begin this exploration with an excerpt from James Merrill's "The Water Hyacinth," in which the poet remembers stories recited to a parent, "the book held close to even then nearsighted eyes." The memories are pleasant, fond.[2]

> *... Once I caught*
> *A gay note in your quiet*
> *The book was upside down.*

But the poem is about the roles reversed and what to do about it.

> *Now all is upside down.*
> *I sit while you babble*
> *I watch your sightless face*
> *Jerked swiftly here and there,*
> *Set in a puzzled frown. ...*
>
> *With you no longer able,*
> *I tried to keep apart,*

*Bruce L. Payne is the director of the leadership program for the Institute of Policy Science and Public Affairs at Duke University.*

*At first, or to set right*
*The stories you would tell. . . .*
*. . . I have them all by heart*

*But cannot now find heart*
*To hinder them from growing*
*Together, wrong, absurd.*
*Do as you must, poor stranger.*
*There is no surer craft*
*To take you where you are going*

Whatever one's joys and comforts, old age brings with it this likelihood of incapacity, and also the loss of friends and a nearness to death. Like Merrill with his father, we may try at first to keep apart, to separate ourselves from the terrors or turn aside from hurts that can't be helped and lives that are not going to be restored. If involving ourselves with these matters is painful, however unavoidable in the long run, trying to put them off may only make them worse.

In advocating help for older visual artists, it seems appropriate to note some necessary limits. This is a discussion about support for some fiercely independent citizens. Our proffered aid will sometimes be rejected. Do you remember Oedipus at Colonus, at the end?

*Children, follow me this way: see now*
*I have become your guide as you were mine:*
*Come: do not touch me: let me alone discover*
*The holy and funereal ground where I*
*Must take the earth to be my shroud.*

Artists may similarly believe, and may have reason to believe, that following their own vision is all the more important at the close of life.

Nevertheless, my sense is that many older artists have real and pressing needs and that help is often welcomed, even precious to them. We can respond, and in doing so make contact with our own hunger for beauty, laughter, meaning or transcendence. Like Antigone and Theseus, we are intending help for those who might yet be our guides, people stronger in some ways than the rest of us. Artists, after all, are sustained by resources of skill and care and insight and, having lived more meditative lives, are probably readier than others to face the approaching dark that none of us can name.

What assistance is required? How can it best be given? What should we do, and why should we do it?

## WHAT DO AGING ARTISTS NEED?

Let me begin with Gert Schiff's *Picasso: The Last Years, 1963-1973.*[3]
Picasso lived those last ten years in Notre Dame de Vie, a large eighteenth-century farmhouse surrounded by cypresses and olive trees, with a view of the Bay of Cannes. There Jacqueline organized everything for him and offered both devotion and inspiration. Schiff recounts an evening in October 1962:

> They sat together in the studio of Notre Dame de Vie, Picasso, his wife Jacqueline, the painter Édouard Pignon and his wife, Hélène Parmelin. . . . The lights were turned off and on one wall appeared a slide projection of Poussin's *Massacre of the Innocents.* For several hours the group discussed every detail of this severe masterpiece, which conveys the whole horror of its subject through the interaction of only four figures. Later that same night they also looked at David's *Sabines.* At first sight this crowded composition seemed to compare poorly with Poussin's condensed image. Yet at closer inspection, it too revealed its strength. Picasso and his friends spent the evening "in a delirium of painterly enthusiasm."

The reality for most artists in their eighties is quite different. Only a few succeed in providing so well for themselves. Hardly any are provided for so well by others or last so long or have such stamina. In fact, if we are to talk about support for older artists, we have to talk about diverse particulars.

There are artists, many of them, who are isolated, and surely many who are unhappy. There are others who are joyful, some self-indulgent, most neurotic like the rest of us. And different purposes inform their work — narrative, psychological, playful, formally experimental and so forth. So the question is complex. What does this artist need and what do these and those and others need? And do their needs have common elements to which we can respond?

We might begin to answer these questions by asking them of the artists — I have spoken to many, though I have taken no random sample — and by paying attention to what we see. I write largely out of what I have learned from the artists who are my friends and from many old folks, also my friends. It should be clear that I mean to speak of serious artists who have been at their careers a long time, mostly artists of recognized quality whose work has been discussed in reviews and has found some place in significant individual or institutional collections.

It is obvious, but worth insisting on, that older artists need money. Few of

these people earn as much from their art as the median income for Americans overall. Most do other jobs at least some of the time, and many depend on support from families. Artists lose time and save money by doing their own carpentry and house painting and often by being their own plumbers and mechanics as well. But without independent means, or a working spouse in another more lucrative field, full-time artists are very likely to have trouble making ends meet.

The evidence from applications to the Adolph Gottlieb and Pollock-Krasner Foundations seems to me overwhelming on this point. Both foundations make funds available to artists in need and both report high levels of need that increase drastically with advancing age. As self-employed professionals with low incomes, artists often go without health insurance and are especially vulnerable economically to injury and disease. They are less likely than others to own their homes. Many, for reasons connected with their art, live in densely populated urban areas – especially New York City. So they are more vulnerable to rent increases or the loss of housing and studio space.

All of these economic difficulties are exacerbated by old age. And patterns of success in the visual arts are erratic at best: there is no reliable way to project and plan for future earnings. While the foundations open to artists in financial need – principally Gottlieb and Pollock-Krasner – are well managed and responsive, they report levels of urgent need far beyond the resources they command.

The economic hardships are real; for many, frightening. But there are other important needs that seem to me far less recognized: praise, community, exhibitions, studio space, storage space, physical and archival assistance, estate planning, housing assistance and other social services. We also should attend to these.

Some years ago in Hannah Geber's studio in New York, I found myself saying how much I liked some particular things about a sculpture on which she had been working. "Oh, thank you," she responded. "You know that is what we artists need – not criticism but praise." She was right, of course, and it's true for all of us. But it is remarkable how few of my artist friends get much praise day to day, week to week, or even year to year, from individuals who see their work and know its context or have some idea of its development.

It is also true that artists – though many of them are, indeed, proud and independent and determinedly alone – need community. They need communities of discourse, contact with others who care about making and seeing.

Even families that are able to provide financial assistance often cannot offer this.

As artists get older, they sometimes get out of touch with their main sources of intellectual support. It may be particularly difficult to make contact with younger painters and sculptors, to see and talk about what is new and valuable in what they are doing, to share one's own ideas and works. One's contemporaries die off, something I didn't realize until my own parents reached their late seventies and I found their generation suddenly disappearing.

Another thing we all need is someone to hear our stories. The narratives, which are really in some way our identity, demand an audience, however small, that cares to hear them. Community means human contact, conversation, warmth. With time, it can become difficult to find.

Artists need to be seen. They need galleries, exhibitions, collectors, even patrons. The currents of fashion do not always run against older painters, but many of them lack the drive, the hustle, the strength to make the most of the opportunities that exist.

For many artists in New York City, over the last several years another urgent matter has been the scarcity of studio space. Even Raphael Soyer, at the end of his life, couldn't hang on to a lease he had managed to keep for thirty years. This is not just a matter of space. Security problems are scarier, because in old age one is more vulnerable. And being old, the need for adequate heat and air conditioning is more strongly felt. Space that once was useful can become intolerable.

Storage represents a similar problem. The longer one works or the less one sells, the more one needs a place to put the works. But that space needs to be safe and at least occasionally accessible.

Storage and exhibition problems are exacerbated by physical disabilities. It gets harder and harder to move the works around. It's most difficult for the sculptors, of course. Most have back problems — even the sons and friends of sculptors are likely to have back problems.

Artists need to provide for their work. It worries them. What will happen to it? Will all the works be dispersed at death? They think about that. They try not to think about it. They may, like Picasso, avoid making wills. But most could use some help in planning, in arranging for the work to be preserved and placed or made available. I once knew a sculptor who left everything to himself, his house and grounds forever dedicated to his own works, except there wasn't money enough to keep the project going. To make

things worse, he had fallen out with all his friends. By the time he died, every one of them had been crossed off the list of executors. This is an absurd case, and a sad one, and isolated—but perhaps it is a symbol of some more widespread despair.

The work needs other kinds of care as well, especially archival care and cataloging assistance. Artists know that they are the only possible source of certain important information about their works. They feel responsible to the works, to the people who may see them and care about them in the future. It's not just their reputation; it's what they've put their lives into. And yet, it is very hard to do alone, and taking the time when time gets short can feel like giving in to age and death.

Of course there are all those other needs that old folks have, for housing and social services, needs made more complicated by society's divided feelings about artists—anger and envy; praise, gratitude and blame.

## WHY SHOULD WE HELP?

There is a fine burst of outrage in Tom Stoppard's *Travesties* when Henry Carr, the self-important former consular employee and former minor actor in Zurich during World War I, blows up at Tristan Tzara:

> Artists are members of a privileged class. Art is absurdly overrated by artists, which is understandable, but what is strange is that it is absurdly overrated by everyone else. . . . When I was at school, on certain afternoons we all had to do what was called Labour—weeding, sweeping, sawing logs for the boiler-room, that kind of thing; but if you had a chit from Matron you were let off to spend the afternoon messing about in the Art Room. Labour or Art. And you've got a chit for *life?* (passionately) *Where did you get it?* What is an artist? For every thousand people there's nine hundred doing the work, ninety doing well, nine doing good, and one lucky bastard who's the artist.[4]

Well, there it is. Why does art matter? How does it matter? The big questions are inescapable if we are going to take seriously the more immediate questions here: are there any reasons to be more concerned for older artists than for older people in general or artists in general?

I think we want to support artists because they produce works that are precious to us, works of *quality*. There's no avoiding that awkward notion. And we have to recognize that quality, except in the very long run, is not very well measured or assisted by the market.

The aspect of quality in which we have the most abiding interest is its

connection with our lives. Good works are those that change us, that change the way we see other works of art, or that alter the ways in which we experience our own lives and the world around us. While almost any work of art might do this to someone now and then, the works that most deserve attention are those likeliest to yield such consequences over time. We ought to prize the works that can be seen intensely, works that can deeply involve the people who are open to them.

Good works, works of quality, may be hard to access. This is especially true of modern works, which are problematic in the same ways as those in which our world is problematic. Their difficulties usually enhance the experience and are inseparable from it. Looking at such work takes faith, or at least some preparation. We don't know what will happen in advance. We have to guess that spending time with a work might give us something that we haven't known or felt before.

For visual works, the art market functions oddly in relation to quality of this kind. We may buy a painting because we have a special experience of it, or because we expect we will, or because others say they have, but ownership will not itself confer what we desire; it is hardly even necessary. Over time, with the collective judgments of curators and connoisseurs, the blue-chip market may more accurately reflect the value of a work for those who hope to see it, but as far as living artists are concerned, this seems likely only in the topmost echelons of success.

The market simply fails to reward artists for much of the value they create. Buyers and heirs, rather than artists, benefit from the increased value that accrues to the works of artists when they die. Real estate owners benefit from artists moving into buildings and then out of them, because artists cannot pay the increased rents that their presence has made possible. The cycle may not be so bad for younger artists, but the costs eventually grow higher and the benefits recede.

For much good work, the market seems inherently inadequate. Because the benefits of art accrue in the long run to people who do not now expect them and to people who do not even yet exist, the value of works of quality is only occasionally and intermittently realized in artists' sales. That the artist continues to create owes something to a gambling instinct — a few artists always strike it rich — but much more to the joys of making fine works and having them affect the lives of others.

Public and philanthropic assistance for older artists can easily be justified to the extent that it secures for the rest of us the creation and preservation of valuable works, and knowledge about them, that would otherwise be

lost or never come into existence. But such assistance, rightly designed, can also help us achieve other values as well.

Robert Penn Warren suggests that poetry, and art in general, is "a sovereign antidote" to the passivity that weakens the texture of our lives.[5] The powerfully anesthetic aspects of our culture are opposed, sometimes defeated, by the aesthetic. We may, for whatever ails us, need our mind-numbing drugs and entertainments. But we need art more — to find our sad and grand and tawdry feelings, to sense the edges of our lives, to see our world more clearly, to be ourselves more fully.

Another reason why we need art, and why older painters and sculptors are particularly to be prized, has to do with the exemplary role of artists. They are believable emblems of freedom, imagination and integrity. They are models for young people, good models, of how to make adventure part of life. For all of us, they are a link to the creative spark or spirit we hope is still inside us.

In this culture we need and hope for lives of greater commitment and intensity. We seek to develop opportunities for "lifelong learning." For these quests artists have long been our avant-garde.

To praise and prize older artists is to emphasize some of what is best and most durable in art. Time is an inexact measure, but over time, quality is easier to estimate. The praise of works developed over time may be a kind of counterweight to the recurrent trendiness and shallowness of the art "scene." Art is, after all, not merely a game for people wanting big winnings nor, worse yet, for self-promoting collectors and profiteers. Attention to older artists can also emphasize the pluralism of quality, the variety of good work that will, in the long run, transcend the rise and fall of fashions.

If we would support the work of older artists because we value art, we also ought to value age itself. In a society that no longer gives much honor or encouragement to older people, everyone's dignity is at risk. Celebrating the integrity of artists who have kept on working can make a small contribution to revising wasteful social values.

Such multifarious considerations are compelling. Support for older artists serves a broad range of values — aesthetic, educational and economic. The problem is to find ways to do it well.

## HOW SHOULD WE HELP?

The most urgent needs of older artists could be better met if the Gottlieb and Pollock-Krasner Foundations had more money or if other foundations,

including perhaps regional ones, could be endowed to follow their example. Carefully considered grants to artists in need have gone to many who are not old; Gottlieb's minimum qualifying standard is an artistic career of twenty years. A specific age range might be reasonable for a new foundation entering the field.

In addition to need-based grants, there are prizes, especially those for life-time achievement, that can confer appropriate honor on a few artists of great distinction. None of the American awards or fellowships go as far as Japan's intensely honorific Living National Treasures program, but taken together they help call public attention to the work of some of our finest artists.

Volunteer Lawyers for the Arts is active on another front, helping many older artists design wills and protect copyrights and studio leases. These efforts, too, are worthy of considerable praise. In this litigious society, having no lawyer can be a terrible handicap.

However, my intention here is not to talk about resources that already exist for older artists, but rather to imagine some alternative ways of responding to the needs I have described. What I have in mind is a series of programs that might be adopted by new foundations or organizations, or by colleges and universities that might benefit from helping older artists.

These programs are not utopian dreams. They are possible now. They require a willingness to help and to praise particular artists in particular places. They also reflect the beliefs that a subsidy model by itself is inadequate and that government and foundation giving is best when complemented by active participation. Artists and those who wish them well can get involved by responding to the problems I have outlined. One further assumption: plans designed in relation to several problems are likely to offer synergistic advantages.

## Storage Space, Exhibitions, Gallery and Museum Relationships

An operating foundation could be created to provide a substantial amount of safe, temperature-controlled warehouse space. That space would be made available to older artists who need it. Transport, safe handling, security and insurance could be provided at costs far lower than are otherwise normally available.

Such a storage space would be designed for easy access to the works, not only by the artists but by curators, dealers and corporate and other art buy-

ers, including friends of the artists. It would have on-site crating and shipping facilities, with some portion of the space devoted to a revolving display of works by the participating artists.

The aim here is both to store the works and to help them be seen and purchased. The foundation would function as an agent, working to secure commercial exhibitions and gallery contracts for the artists, and also assisting interested museums. A commission on works sold at the facility would provide some income to the foundation to help cover the expenses of these activities.

Other income might be provided by making the facilities available, at a fee, to artists not qualifying for assistance. These artists would benefit from lower fees and the satisfaction of joining with colleagues in a way helpful to those whose needs are greatest.

Such a plan supplements the art market rather than ignoring or opposing it. At its best, it might advance artists toward significant commercial and critical success by helping them get their work seen far more broadly.

A nonprofit storage facility of this kind would also solve one of the worst problems of artists' estates. Agreements could assure artists that after their death works could remain at the facility long enough for executors to work out appropriate dispositions. In some circumstances the foundation could even be designated by the artist's will to assist in such disposition.

Where to locate the project? Although artists would no doubt like it to be as close as possible to where they live, the availability of inexpensive warehouse space is probably the most important factor. The minimum requirement would be that it be near an airport. If the idea works well, other locations, probably established as separate organizations, could be found.

There are some other likely ingredients of success. The first is a small board, each member committed to the project. The admission of artists, based on judgments of quality and need, should be the decision of the board or of one or more advisory committees. In terms of need, artists might be admitted only if their income from making art is less than the national median income, or some fraction of it, and if their income from all sources is less than some designated amount.

Judgments of quality are notoriously more difficult. On the other hand, there is no penalty for subjectivity or even for judgments later thought to be mistakes. A board or advisory committee ought to be confident enough of its members to allow less than a majority to select artists. The important thing is that the people connected with the foundation must be willing and

able to defend the quality of their choices.

It might be reasonable to make judgments about quality central, with financial need a qualifying condition. On the other hand, a donor might prefer to design procedures that would make decisions according to severity of need, with some decision as to a minimum level of quality being necessary for admission. The work of artists admitted without need, those paying fees, should meet the same tests of quality that are applied to others.

An emphasis on quality makes sense. If it is there, the work of aiding the artists chosen can be done sincerely and enthusiastically. If quality counts, being included represents a kind of prize, an honor. And making the choices is an education in itself. Those involved will know more and have more to give.

A small professional staff will surely be needed, but there is no reason not to introduce some elements of a cooperative if participating artists live nearby. The exhibition space should have certain hours when it is open to the public—perhaps once a week—but dealers and curators and corporate art buyers should be able to look at work by appointment.

I am painting the picture in this kind of detail because I want to insist that the plan can be fully realized and because I want to suggest the liveliness of it. This would be a different kind of enterprise. It would help with the financial needs of artists, but it would make the art central. If the plan could be combined with studio space, and even living space, so much the better. But even without these additions, the work of such a foundation could create a valuable, ongoing conversation.

## Video Catalogs and Oral Histories

Video technology has become easier to handle. There's no longer any excuse for missing the extraordinary opportunity that video offers us. With a bit of preparation and energy it is easy enough to set up a video camera in an artist's studio and start talking about the work that is there. In most cases, it makes sense to spend a lot of time—days rather than hours. With luck, artists will talk about the whole range of experiences and ideas, painters and movements, friends and groups and circumstances that have left their mark on the work or on the artists' lives.

Oral historians can help those who do this work to think more carefully about listening and about the art of asking, and not asking, questions. But it is more important to be curious than to master a technique. It is also important that the videotapes be copied, with at least one copy for the artist, and that records be kept so that those who might want to use this material later

will be able to track it down.

Video equipment is especially good at providing the raw material for a catalogue. Going through a studio or storage room, setting each work on the easel and asking some questions about it is a fairly painless way of helping to prepare a record. Once an artist dies and the work is dispersed, it may take an art historian endless hours to do only part of what, with so little effort, can be accomplished this way.

The very act of recording an artist with his or her work is empowering. The stories can be told with whatever contradictions and digressions come along. We have interviews that capture some of this for the most notable of our artists. But for very many more who have done good work, who were involved in major movements and changes, who had an effect on others, there is hardly anything.

The job of making these video records would be good experience for any art history student and probably for any aspiring artist. But it may be that many older people themselves would be glad to volunteer. The best thing about such work is that everyone involved is likely to gain considerably from it.

## The College and University Connection

Universities need new ways of dealing with the arts. Their plan of organization — still modeled on the late nineteenth-century German university, with its clear disciplinary boundaries — isn't adequate either for deepening our knowledge or for developing students who are active learners rather than passive consumers of information. For all that can be said in favor of the high degree of professionalism attained by the faculty on most campuses, the sad attendant result has been that the most powerful people in the lives of many academics are the anonymous referees of the professional journals.

That a lot of boring and unreadable prose is being produced for academic journals matters less than the fact that good teaching is often slighted or unrewarded. Beyond this, overwhelming incentives for specialization mitigate against a sense of intellectual community. And there is too little willingness to explore beyond the boundaries of our own expertise, though we urge students to do just that. There are rewards for certain kinds of knowing but few for any kind of doing.

Departments of art history, on the whole, seem inadequate at dealing with living artists. Interdisciplinary committees and programs, on the other hand, might make connections with painters and sculptors, arranging for

them to spend time on campus. These artists' works and lives might be the focus of active inquiry by students.

Universities and colleges have ties to their communities and to local arts programs. They sponsor exhibitions and residencies. Most have not, however, developed coherent strategies to make real educational use of these activities.

My sense is that a focus on helping older artists would give institutions a chance to play a useful role in the visual arts and at the same time to create some unusual educational opportunities and possibly to begin building more solid collections in mid- and late-twentieth-century art. In every field in which students are involved in volunteer activities, we ought to create opportunities for reflection, for talking and writing, for joining action with reflection. In the visual arts this could easily be accomplished. But the right programs have yet to be imagined.

## WHAT DO WE NEED?

A few years ago in Durham, choreographer Bella Lewitzky spoke at an American Dance Festival forum. Someone in the audience asked, rather smugly, whether she didn't think it was wonderful that the dance audience was so much larger than in the old days, that it received so much favorable publicity, and so forth. Lewitzky replied that she wasn't sure the questioner would like her answer very much. "People," she said, "are always talking about broadening the audience. Isn't anyone interested in deepening the audience?"

How can we do that? How can we find for ourselves more of what the arts and the artists have to give us? One of the reasons for my focus in this paper is my belief that for many or most of us the individual artist is the absolutely crucial connection. The words and the silences of artists, the way they work, what they can say of what was easy and what was hard, all help us see art better. The work isn't reducible to biography, but resonance from the life that created it can help us find our way to it. Contrary to some other views, I think this kind of seeing helps us sort out the formal values in a work while at the same time suggesting that formal values are not all that a work has to offer. The first problem in seeing for most of us is beginning.

We also ought to be concerned with older artists because we will ourselves be old. We fear that, and much of our culture encourages us to deny this fact. We even pretend that the old are irrelevant to our modernity, our new knowledge; we conceal their frightening relevance by avoiding those deep questions for which our knowledge may be useless.

The great Russian director Meyerhold used to say, "Art is to life as wine is to grapes." I believe that. And my own sense is that, like Oedipus, older artists have special gifts to give, gifts of complexity and richness, sometimes even of "a more lasting grace than beauty," in Fitzgerald's version of that line. Grace is an undeserved, unexpected good. The forms of support I have suggested seem an opportunity for grace, a way of receiving at last the blessings that these people have spent so much of their lives trying to give us.

Let me close with a few additional lines from Stoppard's *Travesties*, this time the words of James Joyce, that other minor actor who just happened to be in Zurich in 1917:

An artist is the magician put among men to gratify — capriciously — their urge for immortality. The temples are built and brought down around him, continuously and contiguously, from Troy to the fields of Flanders. If there is any meaning in any of it, it is in what survives as art, yes even in the celebration of tyrants, yes even in the celebration of non-entities. What now of the Trojan War if it had been passed over by the artist's touch? Dust. A forgotten expedition prompted by Greek merchants looking for new markets. A minor redistribution of broken pots. But it is we who stand enriched, by a tale of heroes, of a golden apple, a wooden horse, a face that launched a thousand ships — and above all, of Ulysses.

## NOTES

1. Sophocles, *Oedipus at Colonus,* in *Sophocles I* (Chicago: University of Chicago Press, 1954).

2. James Merrill, *Water Street* (New York: Atheneum Press, 1973).

3. Gert Schiff, *Picasso: The Last Years, 1963-1973* (New York: George Braziller, 1983).

4. Tom Stoppard, *Travesties* (New York: Grove Press, 1975).

5. Robert Penn Warren, *Democracy and Poetry* (Cambridge, MA: Harvard University Press, 1975).

# SUPPORT FOR OLDER ARTISTS:
## Comment and Discussion

## SANFORD HIRSCH

Bruce Payne has spoken very poetically, and he has come up with some wonderful ideas, most of which I have seen echoed in grant applications that we have received at the Gottlieb Foundation over the past twelve years. But I differ somewhat with his notion of maturity. Within the Gottlieb Foundation, we define artists as mature on the basis of their having produced mature work for a certain number of years—twenty years for one of our pro- grams, ten years for another.

I am now going to introduce a little prose from one of the artists—excerpts from a grant application we received. Perhaps this will help to make some sense of the statistics we heard this morning, and perhaps it will provide support for some of the ideas that Bruce Payne discussed. I chose the following not because it was unusually dramatic, but because it was typical:

I have been a working artist in New York City since 1951. I have shown at the Stable, the Willard, and AIR galleries. I have written the catalog on Agnes Martin for the Philadelphia Institute of Art. I have worked closely with Robert Wilson on visual design since 1971.

During the past six years I have had to relocate in New York City over seven times because of loft conversions in SoHo and the Lower East Side, each time uprooting my studio and work patterns. I moved finally to this apartment in Jersey City, and now my landlord tells me he has decided to sell this building, which will be converted to expensive condominiums, and I will now have to leave this studio.

I've lost two joints in my feet, which have deteriorated due to arthritic changes. My knees and hips are also arthritic and my doctor advises me to switch my work from substitute teaching in Harlem because of the standing and stair-climbing in grade school teaching.

I have a master's degree in painting from Temple University, which is not recognized by the New York City Board of Education for a regular teaching license, but I make fifty dollars a day as a substitute in various schools. In the past, I have been successful with visiting-artist college teaching jobs, but the present government cutbacks have forced college art departments to severely curtail these teaching jobs, and I can no longer anticipate earning a living from them. I have applied to Westbeth artists' housing and if accepted will be on a three- to ten-year waiting list. I live alone and am 54 years old.

I must pay $500 before the operation as a required deductible and 20 percent of the costs thereafter, and I must pay my monthly premium and incidental bills. If I am evicted during the six weeks following the operation, I must pay storage on my paintings and furniture and sublet rent until I walk well enough to go through relocation. My funds are depleted from the previous seven moves. I'm considering moving upstate to Hudson, Kingston or the Woodstock area after the bilateral surgery, which the doctors say will be six weeks to two months.

I must at the same time find work while I am relocating, which I anticipate to be extremely difficult in communities in which I will be a total stranger. The doctors tell me this operation must be my first priority. I'm finding the tension unbearable — facing eviction, relocation, unemployment and the necessary operation all at once.

My mother, who is eighty-four years old, is extremely ill with high blood pressure in Pittsburgh, which is also a great concern, although she is cared for by her insurance.

On our application forms, we ask for an average annual income for the previous three years. This applicant — a well-known working artist — says that her average income is $7,000, derived mainly from substitute teaching. That's the reality. Statistics can be helpful, but this is the personal reality.

Below is another one, also typical, from an artist who has had an average annual income of $10,000 to $12,000 over the past three years:

On May 4, 1987, I was beaten and stabbed by six youths outside a subway station in Boston. Since that time I have been unemployed due to my injuries and living off funds saved for materials I plan to use over the summer. My budget, though tight, is rapidly being absorbed by rent and day-to-day living expenses. The wounds are on my left side and arm — I'm left-handed — thus preventing me from working while healing.

In closing, let me give you a quick average from the 811 artists' applica-

tions we processed this year: the average household income is $21,000, with an average of two persons in each household. I don't know precisely how that compares with the income for other professions, but I am sure it does not compare well.

## DISCUSSION FROM THE FLOOR

**PRISCILLA MCCUTCHEON:** What about those older people who turn to art in later life? Where should support for that constituency come from?

**BRUCE PAYNE:** Perhaps it could come from older artists, from those who want to be used as this kind of resource. Older artists have a lot to give, and there are those who would be interested in teaching who may find the conventional patterns of teaching too exhausting. It may be that, with a little imagination, we can make use of the older artist to teach some of the people you are talking about. This would not interest a majority of older artists, but some of them do find teaching rewarding.

**CHARLES BERGMAN:** Older artists, by virtue of that extra dimension of pain and rejection, of embarrassment and humiliation, can look upon sources of support with a jaundiced, worldly, cynical eye. At the Pollock-Krasner Foundation, we have given grants to older artists of world-class distinction, whose work hangs in the great museums of the world, who were eating out of garbage cans — and yet they tenaciously refused to give us the financial data that we needed. They were damned if they were going to humiliate themselves by filling out our application, only to be rejected again. We had to use manipulation and contrivance to get from them the financial data we needed so that we could help them.

There are also older artists who, out of the isolation, vagaries and tragedy of their personal lives, are not physically well enough even to complete an application form let alone send sample slides and write a narrative letter. In one case, we had to give a grant in trusteeship, to be administered by someone else for an older artist who was rotting in a nursing home — a distinguished artist whose name would be known to everyone in this room. Our money permitted some very good geriatric psychiatric care, and we brought in an art therapist to work with this artist, who is now going to have an exhibition next year. No one in that nursing home had any idea who he was; no one knew of his rich artistic legacy. So yes, helping the older artist requires very special sensitivities. It is one thing to want to help; it is another thing to take on the actual challenge of doing something.

**SANFORD HIRSCH:** That is a good point. In looking at the applicants that we get at the Gottlieb Foundation, there is a definite line that can be drawn between older and younger artists. It has to do with a person's ability and

willingness to deal with bureaucracy. We heard a lot of statistics this morning, and although they were meaningful, they were phrased in such a way that all the humanity was left out of the situation. By and large, that is how granting organizations present themselves to artists. We have tried at the Gottlieb Foundation — and Charles Bergman at the Pollock-Krasner Foundation has tried — to do just the opposite, to deal with people as people. Older artists have enormous pride. Many of them came through the Depression and feel that it is very humiliating to be seen as needing help. But they need help desperately. We are there to provide that help, but it is the damnedest job in the world to get them to say, "Here I am. I need help."

**JUDY BACA:** Older artists should be models for me as a younger artist, but what occurs is that they go out of fashion. They reach a stage where their work is no longer an important commodity and does not sell. We constantly make the very tiring assumption that the marketplace is going to take care of us. I served with Frank Murphy, from the Times Mirror Foundation in Los Angeles, on a visual arts task force for President Reagan's Commission on the Arts and Humanities, and at one point he said, "Throw the artist into the marketplace and we'll see the best artists." I think that is a prevalent thought, that we are supposed to make it in the marketplace. But I can't tell my older friends where to go for support because I know they are out of fashion. And neither do I know where all the younger artists are going to go — unless we change our thinking about what the function of the artist is in our society.

We are not creative entertainers. If that's what it meant to be an artist, I would no longer do that. I would get myself a high-paying job in a corporation, because I think I have enough brains and talent to make marketable products if I wanted to do that. But many of us are choosing not to do that. We are choosing to be artists. Where do we go?

**BRUCE PAYNE:** I don't think that there are market solutions to all the problems we are talking about, but if our markets were designed better, they could offer more assistance than they are now giving us. Some of the older artists whose work becomes unfashionable in the nationwide marketplace will continue to be esteemed by certain collectors in certain areas. There will always be a small group of collectors who recognize the strength of good work, who continue to go to see it and spend time with it. These kinds of long-term relationships should be encouraged by the market. Whenever an older artist is able to sell work and thereby maintain some independence, some strength, I am always delighted.

We have this notion that the commercial market is over here and philanthropy is over there, and to some extent that is true. But we must think of ways to get beyond this fact.

**JUDY BACA:** Historically, we have not approached the populace in general as a market for artists. Instead, we have approached only a very elite group, a very small segment of the public. If we wanted to broaden our focus, wouldn't it make sense to open our galleries and museums at night for working people? If, in fact, we were looking for a larger art marketplace, would we not be thinking about new ways to market to the general public? My sense is that the few people who buy in the present market are marketed to very well, but expanding the market will require a huge shift of focus. The older artist is not the only victim of the status quo. Others fall out also because of the whole commodity structure.

**SANFORD HIRSCH:** Bruce Payne's description of the community of older artists and their needs is fairly accurate, based on my own experience. As for judging his ideas for solutions, I don't think I have the insight to say that this program is good or that program is bad. All programs are necessary. The needs are so great that no matter how many programs we dream up, more will be needed. At the Gottlieb Foundation, we try to set up programs that will put dollars in the hands of individual working artists without any strings: "You know what you are doing; you have been doing it for some time. We know you need help; here's some money. Do what you can with it." That's the best we can do right now.

**STEPHEN BENEDICT:** What about research? What research needs to be done on the needs of older artists?

**FRED LAZARUS:** One of the difficulties of doing research is getting a good sample; yet through grant applications, the Gottlieb Foundation's sample is constantly replenished and expanded. Is there any way of using that information — or information collected by other agencies in the course of their work — to provide a verifiable statement of issues and needs?

**SANFORD HIRSCH:** This is something that Charles Bergman and I have been saying for a long time. We have the data, and we are very willing to share them. We don't need to go to the Arts Endowment or Bureau of Labor Statistics for data, which aren't even very useful. We have our own statistics about real people.

**BRUCE PAYNE:** When I started working on my paper I went to the literature, and I became very unhappy with the statistics that were turning up. I concluded that nobody could tell me — from the usual sources that public policy people use — what I needed. Frankly, I think the kinds of statistics that these foundations have are what we need; we need to keep track of what the foundations are doing. We need to keep track of the needs that the artists themselves report. These kinds of statistics are powerful and sugges-

tive. People who are trying to help ought to be attentive to the necessity of keeping track of the needs that are uncovered in the course of their work. But at this point the issue is not one of calculating the level of needs; we know the needs are enormous. Let's start trying to meet them without waiting to do much more research. Let's use the information we have, go ahead with our work and learn as we are doing, not learn first and do later.

**STEPHEN BENEDICT:** This roll-up-your-sleeves approach is what Joan Jeffri is doing with the Ten Cities Project, funded by the Ford Foundation and the Arts Endowment. She is collecting extensive data about artist populations which will be used to produce a series of handbooks specifically designed for individual artists. The handbooks will give a comprehensive picture of all the work-related human and social services currently available. These include services available directly to artists from any number of institutions, not only arts organizations — which is particularly important for individuals who are not connected to any organization. This is a way of providing the individual artist with information on existing means of assistance, many of which the artists probably are unaware.

**GEORGE KOCH:** The lack of a supportive infrastructure in their lives is one of the problems most frequently articulated by older artists. Health care is a major concern, as it is for many older Americans, but for artists the circumstances of their activity have necessarily put them in a more vulnerable position since they live and work without institutional support.

We seem to be focusing on those whose needs are most urgent, but at the same time we must not overlook the needs of other artists, lest they, too, become desperate. If there is a long line of artists marching down that same path, somebody ought to say *stop*. Group support *is* available. Some of the most powerful lobbying groups in this country are the older-Americans groups, and there might be some empathy within those groups for the concerns of older artists.

**SANFORD HIRSCH:** The problem with working through organizations for older Americans is that artists are not joiners. They are extremely independent, and the older they get, the more independent they get. Older artists have a problem not only with thinking of themselves as needy but also with thinking of themselves as older. They really don't want to have their positions as artists, their self-esteem, their entire sense of self, denigrated to the status of being simply an older person. They view themselves as active, working individuals, and that's the way they need to be approached.

**STEPHEN BENEDICT:** I have a question for Jack Golodner. Do the case

histories collected by the pension funds contain any data that might be useful to us?

**JACK GOLODNER:** Yes and no. The amount of data available for performing artists is far greater than that for visual artists. Because of the problems mentioned earlier, visual artists are difficult to reach and to help. Consequently, the data needed to fashion public policy are not there in the same quality and quantity as are available for the performing artist.

We have tried for some time to interest the Arts Endowment in conducting studies of the health insurance needs of individual artists because the insurance industry has indicated that they need more data. There are so many misconceptions about artists. For example, most banks consider them to be bad credit risks. But this is not true. Every study that we have been able to do through the performing arts groups shows that the record of artists, as a group, is similar to that of other groups in society. AIDS is another issue fraught with misconceptions regarding its impact on artists. From our studies we've found that, contrary to the prevailing view, artists as a group are not impacted by AIDS to a greater extent than any other occupational group. But we still do not have enough reliable data, and as long as we continue to use data which everybody agrees are faulty, we are not going to make any progress. We can no longer afford to tolerate the mediocre data collection and research efforts of agencies that are supposed to be addressing artists' problems.

.

# support for artists by institutions

# ARTISTS' ORGANIZATIONS

## by Ruby Lerner

*In each city, as time passes, we shall develop a core of established institutions, probably linked with one another. These institutions may tend toward the "safe." But around this core will grow smaller, less solid institutions. For these, life will be increasingly difficult, unless we realize that they may be quite as important, in the long run, to the health of our culture as the core institutions are today.*

— Alvin Toffler[1]

## INTRODUCTION

Toffler's prophecy came to fruition most dramatically in the diverse group of artist-driven organizations that developed across the country during the seventies and early eighties. Organizations grew up in a variety of locations, urban and rural, representing every racial and ethnic community, and in all disciplines — music, dance, theater and visual arts. Artists' spaces, many of which were founded in order to address the needs of visual artists, often expanded to include other art forms as well, particularly the burgeoning exploration of interdisciplinary forms.

The contribution of these organizations has been so enormous it is impossible to imagine what the past ten to fifteen years in the arts would have been like without their presence. In fact, it is fair to say that they have been the strongest evidence of vitality in the arts, since many of the individual artists who found their early "homes" in these organizations went on to make important contributions in their respective fields, either regionally or nationally. Sadly, the artists' organizations providing these spiritual, or actual, "homes" have not yet received either the respect or support due them. Supporting living artists in the process of developing their work, as opposed

*Ruby Lerner is an independent consultant for FEDAPT and the Pennsylvania Council on the Arts; she is also the former executive director of Alternate ROOTS.*

to "packaging" it when its commercial potential has been discerned, is a singularly important task. And yet, support for artist-driven organizations from both public and private sources lags far behind that enjoyed by that core of what Toffler called "safe" institutions. To what extent should public-sector support be used as "venture capital" for calculated risks? How should this capital be invested? These are primary questions for us.

Throughout the 1970s, many artists' organizations were created by people strongly influenced and shaped by their experiences in the sixties. In *The New Entrepreneurs*, Don Gevirtz writes:

> [T]he recent entrepreneurial ascendancy has its roots in a broad-based desire throughout society for great economic and personal self-determination. It owes much to the great individualist rebellions of the 1960s — ranging from the Goldwater movement on the right to the student New Left. Both movements sought to break the tutelage of the large, bureaucratic institutions that dominated American economic and political life . . . .[2] As Daniel Yankelovich has observed, the new "cultural revolution" is based on opposition to "instrumentalism," the use of people as tools of production and distribution.

It is helpful to look at the artists' organization movement as part of this greater movement, to see its simultaneous commitment to the idea that people working together could bring about change more effectively than individuals working alone.

The traditional not-for-profits were perceived as presenting work that was "safe" artistically. Salability was the obvious motivating force for the commercial world. Artists' organizations were created by artists shut out of opportunities to exhibit or perform their own, perhaps more daring, work in existing venues such as commercial galleries, museums and regional theaters. These new organizations would be non-elitist and would attract culturally diverse audiences. They hoped to build a broad base of community support rather than rely on the patronage of the wealthy few.

In short, a new kind of organization was envisioned: one that would be more adventurous artistically, less bureaucratic in organization, able to respond directly to the changing needs of local artists. They were generally created by a group of local artists who saw the space as providing a "home," an ongoing community of support, for their individual work. Often they were housed in abandoned school buildings and warehouses in low- and middle-income neighborhoods. These were fundamentally risk-taking organizations, and policies were set by those who would be affected by them.

Along the way organizations incorporated in order to be eligible for

grants from public sources and an occasional adventurous foundation. Legally necessary boards of directors were usually composed of the founding artists and a few friends. Very little money was being raised from private sources such as wealthy individuals or large businesses.

The local work presented was often dynamic and exciting, if sometimes erratic. One of the needs expressed by local artists was to see the artwork being created by peers from other places, which until recently meant New York, and to have the opportunity to interact with those artists.

At that time the level of organizational sophistication was the minimum required to get tasks accomplished. As growth began to seem desirable and necessary in order to address the needs of local artists, several things began to occur. Artists began to spend more time on administrative matters than on making art. Some even gave up their art to become full-time administrators, or the organizations hired outside managers. Boards were expanded to include people from the community who, it was hoped, would assist with additional fundraising. Many organizations experienced significant changes, often without realizing the implications of such changes until much later. The past few years have seen an awakening to questions inherent in organizational development. Now these issues must be addressed.

## Definition and Purpose

Terry Wolverton of The Woman's Building in Los Angeles has stated: "Rather than give in to either fashion or conservatism, I'd like to encourage artist-run spaces to remember where we came from and why: to expand the narrow definitions of what is considered art and who is legitimized as artist." Artists' organizations are proud of these goals and have successfully brought these things about. However, achieving this purpose today is not as simple as it may seem at first glance.

In the 1970s, when many of these organizations were founded, there was a shared understanding of what it meant to be "alternative." Such a consensus may be unattainable now, in part because of the field's success. Some have observed that artists' organizations may only be "farm teams for the major leagues." Others maintain that these organizations have been, and should strive to remain, an integral part of a total, alternative culture.

The "Rochester Gathering" — a 1986 meeting of administrators and artists hosted by the Visual Studies Workshop in Rochester, New York — designated "increased involvement in sociopolitical issues" as a priority.[3] Has the social and political content of the work presented by artists' or-

ganizations changed over time? The causes of these changes, the trend toward or away from sociopolitical content, should be examined.

The artists served by these organizations represent another issue. Emerging artists who initially found their "homes" in artists' organizations are now in midcareer. Can we continue to nurture their careers while promoting the emerging generation of artists? Must we choose between them? This issue stems from the field's success. Its resolution hinges on, and will affect, our definition of artists' organizations.

In some organizations there has been a gradual devaluing of the local. Presentation of work by artists from outside the community slowly began to eclipse work by local artists. This began as a way for local artists to see work by their peers, but it was easier to fundraise for such exhibits and performances. Local work came to be considered less glamorous. The result was fewer opportunities for local artists to present their work. Programs to develop the work of local artists, to build audiences and gain support for those local artists, were never put into place. A "trade deficit" was created. Organizations focused on importing the work of "stars" in the field rather than exporting the work of local artists or establishing mutual exchange of work. Now, with growing decentralization and recognition of gifted artists living throughout the country, the focus has again been widened. Nonetheless, frustration often remains on the part of local artists.

## The Process of Institutionalization

Many people in the field recognize that the process of institutionalization, of working to guarantee the survival of the founders' ideas, has altered to some extent the founding purposes of artists' organizations. In 1979 Paul Weidner, upon resigning from his post as the founding director of the Hartford Stage Company, described this paradox:

> I have a growing fear for the resident theatres now that they have become arts institutions. In becoming an arts institution, there is a great danger: the demands of the institution begin to dominate the demands of the art. . . . Artists must assert and reassert themselves; otherwise these institutions will turn into businesses.

Mary MacArthur Griffin expressed a similar sentiment:

> I feel that the history of religious institutions prefigures that of many artists' spaces. They began with high ideals and no money and are a little compromised by success. They've been pushed into making themselves silk purses when they were perfectly good sow's ears. They've been encouraged by certain funders (who never raised a penny and never ran an

artists' space) to take General Motors as a paradigm in the composition
of their boards of directors, to inaugurate development campaigns and
earned income programs and, in the sacred cause of "audience develop-
ment," to program "accessible" work – a lot of strings trail from
erstwhile free spirits.

These observations raise the question: Is continuance alone a valid pur-
pose for an organization? A way must be found to transfer the founding,
entrepreneurial spirit of these organizations to second-generation leader-
ship. But perhaps artists' organizations have committed to do too much.
They find their goals extended beyond the energies and capabilities of
limited staff, creating an over-taxing work environment for staff and sup-
porters. The result is burn-out and the loss of valuable human resources.

## The Idea of Growth

Some observers take for granted that growth is the primary measurement
of success in the institutional process. Arts organizations have often ac-
cepted this yardstick without question. As a result, we are unable to deter-
mine the criteria for evaluating our success. The growth we covet is some-
times inorganic: a significant leap in membership numbers, a move to a
larger space. Such spasmodic growth puts demands on the organization that
are difficult to meet over the long haul. Further, when we consider the
corpo-rate example in today's economic climate, with its mergers and un-
friendly takeovers, and see the negative example it provides of growth as an
end in itself, such a yardstick of success seems all the less desirable. Pursu-
ing growth for its own sake is even less appropriate when, in a time of
shrinking public resources, competition for public- and private-sector sup-
port excludes, to some extent, vital social services.

## Identifying a Model of Institutional Development

There have often been external pressures on arts organizations to look a
certain way structurally. It was assumed that a hierarchical structure, like
the traditional, large business model developed at the turn of the century,
would be the best structure for arts organizations in the late twentieth cen-
tury. Ironically, enlightened businesses consider this model a liability that
lessens productivity. Today, many young, small businesses, like the entre-
preneurial artists' organizations, blatantly reject those old structures and
create organizational structures appropriate to their business.

*Re-Inventing The Corporation,* by John Naisbett and Patricia Aburdene,

documents the success of these new business models.[4] The authors state: "[T]here is a growing recognition that yesterday's hierarchical structures do not work in the new information society. Yet the question is: If not bureaucracy, what? Most of us do not know how to organize ourselves any other way." What Naisbett and Aburdene examine in the context of business is equally relevant for artists' organizations.

Artists creating their own organizations developed other ways to organize themselves, at least in the beginning. But in the arts world of the late 1970s and early 1980s there was little encouragement for these odd, unrecognizable structures. Judy Moran and Renny Pritikin of New Langton Arts in San Francisco point out: "Structurally artists' organizations today have come to resemble museums—the consensual anarchy of the early years having by necessity faded away to a more traditionally hierarchic form."

This movement toward a "more traditionally hierarchic form" became a necessity to some extent because of retaliation directed toward nontraditional organizations in the form of limited or totally denied funding. Often this retaliation was directed against them, not because a funder necessarily disapproved, but because the funder may have been unaware of the efficacy of such unconventional solutions. Harvard business scholar George Lodge has said that any force of change will fail without protection from the inevitable retaliation of the status quo. Nello McDaniel, executive director of FEDAPT, interpreted that statement:

This language sounds harsh and sinister, as though the status quo were actively and blatantly working to eliminate change. Most often, however, the retaliation is very subtle and derives from genuine interest in and concern for the artists or their organization. But any time a small group tries a new structure and is forced back into a traditional mode because guidelines require certain quantitative procedures, this is retaliation.

As artists' organizations strove to survive, there was little time to campaign for the acceptance of diverse structures. There was too much other work to be done. Also, little appropriate technical assistance was available to artist-driven organizations. The scenario was as follows: once an organization was ready to "grow up," it cast its nontraditional structure aside to adopt a more recognizable, usually more hierarchical one—ironically more like the large, traditional organizations to which they were founded as an alternative.

Some artists' organizations strive to be both alternative and successful in-

stitutions in our society. This is a difficult task, since they must search for or adapt models from the art world or elsewhere — nonprofit and profit-making organizations — perhaps even from other cultures. Documentation of structures that can satisfy such complex needs is hard to come by, yet finding it is imperative.

## ISSUES FACING ARTISTS' ORGANIZATIONS

### Governance

Governance has been a particularly touchy issue for artists' organizations. Often governed completely by founding artists at the start, most artists' organizations still retain artist participation at the board level, sometimes as a mandate of their mission statement or charter of incorporation. Artist control over programming is also seen as a vitally important tenet. Indeed, "one contribution of the field has been an emphasis on the communication of artists' ideas in exhibitions, rather than shows displaying curators' concerns," state Moran and Pritikin.

As boards of directors have grown to include nonartists from the community, they make decisions on institutional issues separate from actual programming, but that clearly have an impact on it. The participation of artists, their role on the board, may be limited to the legitimizing of decisions and policies with which they may not always agree. Artists and their needs may become marginalized in such situations. In some cases, artists or staff have been gradually removed from policy-making positions to make way for more "important" people from the community. If an organization slowly shifts from being artist-driven to being board-driven, what are the ramifications? Can this be positive for some organizations?

In fact, recruiting highly placed business and community figures to our boards became another criterion for measuring success. Lack of any previous involvement with the organization was often overlooked. A perceptive analysis of this situation is offered by Leon Denmark of the Negro Ensemble Company:

> Everywhere you turned, you would find arts organizations recruiting vice presidents of this corporation, of that corporation, prominent political figures, and well known and less known social figures, and attempting to recruit wealthy patrons. . . . And here we are. I would venture to say that for the last five years most of us have had boards of directors made up of new people, good people, people who have had the best interests of our groups at heart. I am equally sure that most of us have concluded that there are only one or two wealthy patrons in town and that someone

else has them; that the lawyer and the accountant on the board really don't have the time to give the arts organization the help it needs; and that as beneficial as it may be to have as board members the vice president of public affairs of a large corporation or even the vice president of a bank, this does not eliminate the organization's financial difficulties.

Difficulties in fundraising are often cited as the reason for artists' diminished roles on boards of directors. Initially, artists were relieved to be able to step away from the tremendous responsibility and get back to their art work. Unfortunately this well-meaning stepping away became abdication of responsibility and authority. Programming authority and institutional authority are not the same.

Organizations may appear more successful as management becomes more professional, the board begins to be filled with as many influential people from the community as can be gathered, and the physical space gets spruced up. These are the positive, tangible results. In the meantime the organization may be experiencing a great deal of "quiet" internal stress: a dissatisfied staff, tensions between staff and the board, a sense of disenfranchisement and betrayal on the part of the local artist community.

While it is true that, to some extent, more money can usually be raised from private sources by increasing the number of influential community members on the board, many artists' organizations still cite the board's failure to raise enough support as an ongoing frustration. Using larger, more traditional organizations as our models, it is easy to be seduced into believing that if only we had certain people on our boards, our problems would be solved. These expectations may be misguided. We may find that we never understood the real cost of that support.

To what extent has institutionalization created unrealistic expectations within arts organizations, especially in the area of financial support? In spite of the tremendous accomplishments of the field, successful fundraising from private sources, particularly from business, remains elusive. For a number of years, organizations hoped that corporations would "take up the slack" left by decreasing federal funding and increasing competition for state and local support. While we have seen and continue to see substantial corporate giving to traditional arts organizations, much less has "trickled down" to nontraditional arts organizations who present alternative work.

## Real Estate

Artists and artists' organizations have played a powerful role in real estate development. But what happens most often is that developers swoop in

after an undesirable area has been "cleaned up" by artists who may have spent years creating and upgrading facilities, only to be forced by the developers to vacate them. Do other, more humane types of community development models exist that might include these artists as partners? Are there new or different alliances that could be formed in the community?

## Cultural Diversity

Unfortunately, there are still problems of racism and discrimination in the arts. Although white artists are perhaps aware of, and even sensitized to, the situation faced by peers in other racial and ethnic groups, the elimination of racism has simply not been a priority for whites. All artists' organizations struggle, but we must recognize that the prejudices that remain in society at large make growth and development even more difficult for organizations founded and run by racial and ethnic minorities. Society pays lip service to diversity. But there is a difference between tolerance of diversity and respect for that diversity. As a society, we have achieved only a tenuous tolerance. How can we move from tolerance, or even appreciation, to respect? This remains to be addressed by society and by artists' organizations.

As Terry Wolverton points out, the issue is one of inclusion:

What is culture and who makes it? Whose words, images, experiences, sensibilities, values and concerns will be passed on to future generations? Who is entitled to create civilization? Will it be only white men, educated by particular institutions, working in approved styles and media, dealing with acceptable content (or no content at all)?

The Rochester Gathering identified "visibility of cultural diversity" as a priority. It is easy to endorse pluralism. The measure and depth of our commitment will be reflected in specific programs we create to move closer to respect for diversity.

Like racism, sexism continues to pervade our society. The statistics on income levels and exhibition opportunities for women artists in the late eighties are shameful. Wolverton reports that "although women are more than 50 percent of art students and 38 percent of professional artists, their work is presented in mainstream institutions only about 10 percent of the time." Income levels are only 42 percent of those for male artists. The issue of inclusion with regard to women artists will continue to be taken up by artists' organizations, and as with racism, the creation of specific programs to address sexism will reveal the depth of concern for this issue as well.

## Documentation

Honest and full documentation is of vital importance for artists' organizations. Their histories, their accomplishments and the issues they face must be available to them and to future generations. Much can be learned from their success their shortcomings, the structures they choose and even their demise.

## Summary

The issues facing artists' organizations are critical ones. There is no one set of right answers, and each organization must answer these questions for itself. We have neither time nor resources to continue without careful self-examination and fresh commitment. Leonard Hunter of the Headlands Art Center in San Francisco, California, suggests:

> We might begin approaching change by reconceptualizing the purposes of artists' organizations. For example, they can be conceived as community-based and nationally connected support systems for nurturing alternative ideas and possibilities. Some may think of them as connectors, leveragers, advocators, and power brokers with the forces of the city. There are many ways to rethink them; the important thing is to begin. We might begin by asking ourselves tough questions such as: Why continue to "expand"? (as if growth itself were of inherent value); or to "stabilize"? to remain nonprofit? to maintain museum-like boards? to hold real estate? to mount exhibitions in gallery spaces? to bind themselves structurally to artists' un-self-examined impulses? Ultimately, artists are change agents, and artists' organizations are the new multi-celled complex organism evolved from the single-cell lone artist.

Technical assistance, offered us with good intentions, has helped us adapt to prevailing realities. But by and large, artists' organizations were founded by individuals committed to change. Therefore, while acknowledging current realities, shouldn't technical assistance also prepare us to bring about the changes necessary to create the kinds of organizations we want and need?

## TECHNICAL ASSISTANCE

In *The Aquarian Conspiracy,* author Marilyn Ferguson observed that sometimes, long after an old paradigm has lost its value, it continues to command allegiance.[5] The first step in breaking such an allegiance is to question the hidden assumptions — to call attention to inherent contradictions.

The assumptions of previous technical assistance programs now require scrutiny.

The generation of organizations born prior to and during the 1960s received some management technical assistance from the business community. They also discovered a good bit on their own, through trial and error. When the first college credit course in arts management was initiated in 1963 at the New School for Social Research in New York City, a new profession was born. In *The Culture Consumers,* Alvin Toffler writes of that time:

> [N]ot only is an influential new profession arising, but it comes at a moment when other forces within the institution are losing influence. The displacement of the individual donors of great wealth by a combination of small donors, businesses, foundations and others has created a shift in the internal power balance within the institution. With the purse strings no longer so tightly gripped by a single fist, the manager is now freer than in the past to assert his own influence.[6]

It is fair to say that during subsequent years, the influence of managers upon arts organizations was substantial. Toffler described the ideal bureaucrat as "the opposite of the adventurer. He prefers safety and stability to innovation and experiment. He wants things comfortable and predictable. He is under pressure to produce measurable results." While recognizing the dangers of bureaucracy, Toffler also enumerated its benefits — continuity, planning and efficiency.

Safety and stability, comfort and predictability, are anathema to artistic exploration, even though a safe and stable environment may be conducive to that exploration. A fundamental tension emerges. The "order" of the artistic process is far from apparent; in fact, it may appear chaotic, while the "order" in management is easy to discern. "In this country we have prized organizational ability over the creative impulse; prized and rewarded it," wrote critic Donal Henehan in the *New York Times* several years ago. In spite of rhetoric to the contrary, one of the subtle results of technical assistance has been to secure the supremacy of management over art.

We have paid much lip service to management that supports artists without dictating to them, but that kind of management remains a rarity. Further, we believed good management would allow artists the freedom to create artwork and relieve them of the burden of making important decisions about their organizations. This seemingly benign attitude actually infantilizes artists by presuming that someone other than themselves knows

what is best for them. As a result, artists abdicate responsibility for their own organizations.

## Assumptions of Past Programs

The management technical assistance available to the diverse arts organizations that sprouted up in the 1970s grew out of what had been learned by the previous generation of arts managers and from their experiences in large, traditional institutions. The philosophical assumptions inherent in their approach have remained largely unexamined.

The most sweeping and unacknowledged assumption is that management structures, decision-making processes and implementation strategies are value-free. Therefore, though it might be necessary to have a hierarchical management structure or a board of wealthy patrons in order to attract sufficient support, it was assumed that the art presented would not be affected. Incongruity between the art presented and the management style was allowed and even encouraged. But management decisions are value-laden. The choices made in those areas clearly affect the nature and quality of the relationships among artists, between artists and managers, and between the organization and its various constituencies. Further, management style and organizational structure eventually will have an impact on the art presented, even if it is not initially apparent.

Institutionalization, continuance beyond the participation of the founders, was assumed to be a universal goal, a good in and of itself. Indicating publicly that such a goal might not be the primary reason for being was viewed as an invalidation of the artwork you were doing. In addition, it was frowned upon because it made fundraising more difficult, or even impossible.

Since second- and third-generation organizations were learning from managers whose experiences were generally in "red carpet" institutions, there was a host of operating assumptions that also went unmentioned. Artist-run organizations — that is, those with artists working as staff or serving on the board — were seen as hopeless and thus were never really given a chance. Hence, technical assistance programs to help artist-run organizations operate better were never designed. Technical assistance was not geared toward helping organizations with nontraditional structures. Rather, these organizations were told that maturity meant abandoning such adolescent styles. This advice was always well-meaning; it was based on the prevailing reality that the private sector is very slow to respond to organizations who, though their artwork might be quite dynamic, are structured in nontraditional ways. Unfortunately this is still true, often even of the public sec-

tor as well. "Behavior modification" began to occur as external pressures forced a homogeneity of structure and management style that was often at odds with the missions of artists' organizations.

Much arts management technical assistance was predicated on the view that "bigger is better" and the assumption that there is "one right way to do things." Such assistance employed strategies that had worked in building support for larger arts organizations whose audience was the two to five percent of the general population that attends arts events. Well-meaning consultants assumed that what worked big would work small, that what worked for an organization when it was "the only game in town" would continue to work when the number of organizations in an area began to multiply more rapidly than anyone could have predicted.

In large measure, what worked for big arts institutions had been borrowed from the world of big business. Whatever new "quick fix" the business world discovered was rapidly adapted for use by the arts community. Nowhere can this be seen more clearly than in the field of arts marketing. It provides just one example of how inappropriate some types of technical assistance can be — when borrowed medicines are used to treat symptoms while the structural imbalances causing them go unnoticed.

## Arts Marketing as an Example

Arts marketing is based on the fundamental tenet that we are addressing only about 2 to 5 percent of the population in any given area. For a time, direct mail was king. It was inexpensive and for a few years it was possible to make impressive gains simply by mailing out more brochures. The basic profile of the person who responded to direct mail had been clearly ascertained: white, over thirty-five, well educated, with annual income in excess of $35,000. There is no arts organization in America that has as its stated mission: "We exist to serve affluent white people with master's degrees." Yet while no organization set out to appeal solely to this group, we did not fully understand the consequences of using direct mail, nor did we understand its limitations. The seeming utopia disintegrated rapidly as the bulk mail stacked in people's mailboxes began to reach the saturation point, member renewal rates began to decline, and mailing and printing costs soared.

Telemarketing seemed an attractive alternative. Most arts organizations were already in the habit of calling nonrenewed subscribers, and this technique soon became a substitute for large-scale direct mail campaigns. It used the same lists of names that previously would have received direct mail solicitations, but telemarketing was faster and more direct. Of course, we

were still swimming around in that same 2- to 5-percent universe. Even in a mid-sized city, five to seven arts organizations might be doing simultaneous phoning. If an arts-goer happened to be on the right list, he or she might be barraged with phone calls—the saturation phenomenon once again.

When an arts organization brings in an outside firm to do the calling, commissions and fees can get quite expensive. We have heard about massive gains garnered through telemarketing, but it is more difficult to get information on the attrition rate. One theater reported expansion from 12,000 to 26,000 subscribers through a massive telemarketing effort. But the very next year they were back down to 17,000—a loss of 9,000 subscribers. When budget projections are based on ongoing subscription revenues from 26,000 people, and the actual subscription base dwindles to 17,000, the danger of inorganic and unsustainable growth becomes apparent.

VALS—Values and Lifestyles Segments—is another recent addition to the marketing lexicon. VALS reduces the public to nine distinct classifications that move beyond demographics to something called "psychographics," which delineate people's attitudes and opinions in an effort to predict behavior. Many people disapprove of this kind of categorization. More significantly, it seems simply to be a technique for dissecting that same 2 to 5 percent, giving them new names—the "experientials," the "societally conscious," and so forth.

On the other hand, some arts presenters have become fascinated by the conclusions of VALS research. But do we need expensive surveys to tell us that more people will want to see *The Nutcracker* than a postmodern dance company? Does this mean a presenter shouldn't present postmodern dance, or that we shouldn't keep trying to reach those people who, in the VALS typology, are not arts-goers? The positive thing that VALS has done is to remind us that, rather than focus solely on who we are and what we have to offer, we need to understand the people to whom we are talking, to know what their needs are, and to communicate the quality of the experience they will have as an audience member. Unfortunately, VALS has resulted in photographs of wine bottles on arts brochures, but that is more the fault of our own limited imaginations.

The latest "quick fix" is called "response enhancement," a computerized marketing technique that analyzes mailing lists on a name-by-name basis. A model is built, based on the subscriber/member history of the institution. Names and addresses of those who subscribe are analyzed by computer for similarities in zip code, salary, age, education. In addition, subscriber/member names are compared to mailing lists from other arts institutions and from magazines and department stores. A profile is developed of the

magazines members read, the shops they frequent, their religion, whether they are members elsewhere, and other characteristics. Every name submitted is compared to the same lists that were used to build the member model, and each name is given a rank from A to K (where A has the most characteristics in common with current buyers). The theory is that this will increase efficiency by enabling an organization to mail to fewer households – those most likely to respond. This is a very expensive process, and if it is used, organizations can and should do at least part of this work themselves, in-house and for free.

Arts marketing has led us to adopt terms like "product," "consumer" and "targeting" – a language of exploitation – without understanding that this language might define and determine the nature of our relationships. In the arts, the title shifted from "audience development director" to "marketing director" in an attempt to achieve parity with business.

It is tempting to sit and wait for the next new trick from the business world. Though costly, these tools and techniques have some merit. The mail and the phone are vital to our existence. But throughout the seventies and early eighties, few organizations examined the messages inherent in mass-marketing tools. We need consciously to consider what might be the most appropriate, effective ways to use such tools rather than simply to assume that we will use them if we have the money.

We failed to see the ramifications of using such tools, failed to ask ourselves if they helped us build the kind of relationships we want with our audiences. The availability of these tools and their partial effectiveness seduced us into believing that they could substitute for personal effort. They seemed to lighten our load, to do our homework for us, and that led us to think we were relieved of the responsibility for speaking directly with our audience.

Because these tools promise such massive gains, at least in the short term, they have subtly given us the sense that the current audience is disposable. We have leapt over the responsibility for building long-term, deeper relationships with people who already support us and focused our attention instead on those elusive and possibly even imaginary people who might support us. These tools exacerbate what I feel is one of our most pressing problems: a depersonalization in the way we attract people to our organizations and our work.

Marketing is only one area, but it illustrates the path we have taken. In

*Art Criticism* in 1984, Donald Kuspit wrote:

The depth of art's transformative intention toward the world has become obscured — to the extent that art seems to have lost all subliminal force — by its commodity identity and its broad culture industry uses as a ratification of the status quo of social appearances as well as principles, that is, its use as another administrative technique of control.

Many of the assumptions outlined above were made at a time when financial and human resources seemed unlimited. For a while it appeared that many of the methods and prescriptions that worked for traditional organizations might work for nontraditional organizations as well. Now, even some of the traditional organizations — as they experience falling renewal rates, more and more money spent to bring in new members and other such problems — are beginning to question these tools. It is fair, however, to say that some of those methods have worked and still might work for nontraditional organizations, if only in the short term.

Using these methods may have altered nontraditional organizations in unintended, and perhaps undesirable, ways. This has contributed in part to the confusion over the definition, purpose and, most important, the future of the field. Examination of traditional technical assistance reveals certain shortcomings, even when the motives on both sides were well meaning, if uninformed. If we look at our past experiences and integrate what we learn with new information about our environment and ourselves, we may discover where it is best to diverge from traditional technical assistance, so that we can build different kinds of institutions. Though past experience has barely receded enough for us to engage in beneficial analysis, we must ask ourselves what kind of technical assistance will be appropriate for our nontraditional organizations in a time of ever-accelerating change.

## THE CHANGING ENVIRONMENT

The massive changes we are experiencing as a society have been well chronicled lately. Sociologists, journalists, political observers, futurists, demographers and business forecasters are attempting to interpret our own moment in history and predict our future. It is clear that the changes confronting us will have, or are already having, significant impact on arts organizations. In order to see those changes as an opportunity and a challenge, rather than as a baffling scenario in which we are the victims, we need a working knowledge of our environment and how it is changing.

We often make impressive three- or five-year plans for our arts organizations without taking into account the sweeping changes in our communi-

ties—changes that could render our plans obsolete as soon as they are put on paper. A number of areas have an impact on the arts—population movement and changing demographics, increasing privatization of services, technology and the increasing number of arts organizations and leisure choices in general, to name just a few.

A brief examination of these areas demonstrates that it is crucial for artists' organizations to begin their self-examination by placing themselves in the context of the environment—which can be seen as including broad national, perhaps even global trends and issues, as well as local ones. These trends are experienced most directly in our own locales, where our experience confirms or denies them.

## Mobility and Demographics

People began moving from rural America into cities around 1820. In 1910, for the first time, the "typical" American lived in an industrialized city. During most of the twentieth century, small towns withered, drained by migration to the cities. It seemed that cities would never stop growing. But in the 1970s, almost three million more people moved out of large urban centers than moved into them. Nearly two-thirds of all nonmetropolitan counties gained immigrants, compared with one-tenth in the 1950s. This has changed our definition of "rural." In this recent migration, the arts and artists found their way into new corners of the country.

In the 1980s, however, metropolitan areas again grew faster than rural areas. The startling result is that 45 percent of all Americans now live in suburbs. But today's suburbs are not the ones we would like to remember—the image of a downtown hub to which suburbanites commute on a daily basis for work and entertainment. In fact, by 1975, fewer than half of all suburban workers commuted to a job in the central city.

Richard Louv, journalist and author of *America II,* writes:

The old type of zoning, which had everybody living here in the "burbs" and working there downtown is for the most part giving way to "mixed-use" zoning; in the new suburbs, people work closer to home, or at least have that option. [These areas] lack strong downtowns, and population tends to group into what demographers call clusters and nodes, sprawling, booming blobs dominated by strip developments and freeways. But population is growing, steadily and rapidly.[7]

Louv points out that we are often fooled by the gentrification of urban areas, believing that our cities are "coming back." He goes on to say that though they may be coming back aesthetically, a process in which cultural

organizations have played a major role, they are not coming back in terms of population. We do not yet understand the dominance of the shopping mall. Louv suggests that malls represent new downtowns: "Political pressure should be brought to bear to make them public, to make it okay to hand out leaflets, to hold public events and performances, to do all the things that, in the past, gave life and liveliness to America's main streets."

Clearly this movement of the population, particularly the high percentage living and working in the suburbs, has tremendous ramifications for artists working in urban areas, and the increasing number of center city arts organizations. A city like Atlanta, whose Standard Metropolitan Statistical Area count boasts a population of over two million, has an actual city population of only 500,000. Can a population of this size support the more than one hundred arts organizations located there? Arts organizations are currently attempting to figure out how to get people from outside the city—clearly a larger pool from which to draw—to come into town. If, in fact, this group rarely makes this journey, shouldn't we consider satellite art centers and local touring by city artists in the future? Won't these areas eventually want their own organizations?

It is also significant that, between March 1983 and March 1984, almost 17 percent of the population moved, an increase of two million over the previous year. Our efforts in the arts have traditionally, and appropriately, been geared toward building constancy, an ongoing relationship with our audiences. Might this kind of population movement defeat our efforts?

Other statistics reflect the changing complexion of our communities: about 26 percent of population growth in 1985 was due to immigration; two-thirds of the world's immigration is to the United States; and an estimated 29 percent of the net growth in the work force through the year 2000 will be in minority groups. How are the cultural needs of these new population groups being met?

It is important to note that countries of the developed West represented 30 percent of the world's population in 1900; today they represent only 15 percent. The white population is now only 18 percent of the world total and declining. The exciting aesthetic impact of these changes can be seen in the increasing visibility and influence of black, Hispanic and Asian arts in this country.

According to the 1986 Bureau of the Census, Current Population Reports (Series P60, #157), 19.1 percent of the population has an annual household income of less than $10,000, another 20.9 percent has a household income of $10,000-$20,000, and another 18.3 percent has a household

income of $20,000-$30,000. In other words, about 60 percent of the population has a household income of $30,000 or less. Maybe what we have really always wanted was broad-based support from this 60 percent. We may even have understood that it would be better to raise $100 a year from a thousand people than $10,000 from ten people. But we were not prepared for the incredible amount of work this requires. So instead we have sought larger gifts from fewer people or fewer agencies to avoid increasing our already overburdened workloads. Many arts organizations want to reach the lower- and middle-income groups, but are they prepared to accept what might be a reduced level of support—the support that this constituency can afford?

In 1985 persons living alone accounted for 24 percent of all households, an increase of 13 percent over 1960. Single parents headed 8.8 million households; the number was 3.8 million in 1970. About 23 percent of children under age eighteen lived with only one parent in 1985. There are now 52.4 million women in the labor force, up from 23.2 million in 1960, and women will account for 63 percent of the people entering the labor force in the next fifteen years. Thus we have the two-career household. Traditionally, women have played a significant role as volunteers in our organizations and as planners of cultural activities for the family. Is this recent change in women's lifestyles having an impact on our ability to get the volunteers we need? Are our solicitations for help now competing with the sheer exhaustion of women who are struggling to balance career and family life?

Americans are growing older. Today there are more people over sixty-five than under eighteen. Life expectancy at birth has increased to 74.7 years, and people older than sixty-five constitute the nation's second richest age group—only those fifty-three to sixty-four are better off. With our senior citizen discounts, are we subsidizing one of the wealthiest population groups? Perhaps we should think about subsidy based on income, rather than the age-based subsidies we currently offer senior citizens and students. Equally deserving of consideration—and something a number of arts organizations have already begun to explore—is the possibility of recruiting senior citizens, who as a group may have more time available than women, as a volunteer corps.

About 19 percent of people age twenty-five and over had completed four years of college by 1985, as compared with five percent in 1940. At first glance, this better educated population might look promising for arts organizations. However, the career focus of today's colleges and their students may be creating a group of adults who know little about the arts and have little interest in cultural experiences.

Every day forty American teenagers give birth to their third child. In September 1986 more than 3.6 million children began their formal schooling in the United States. One out of four were from families who live in poverty. Fourteen percent were children of teenage mothers. Fifteen percent were physically or mentally handicapped. Fifteen percent were immigrants who speak a language other than English. Fourteen percent were children of unmarried parents. One out of four will not finish school. Forty percent will live in a broken home before they reach eighteen.

Although it is difficult to imagine the impact these facts will have on our organizations in the future, it is important to know about the world in which we live. We must attempt to understand the ramifications of this information as we define, or redefine, our purpose and as we engage in organizational planning.

---

## Privatization

Richard Louv describes the "clusters and nodes" into which the American population is forming as "completely self-sufficient, planned communities." He goes on to say:

> ... for the first time in our history, municipal and county governments and all other traditional forms of local government have a serious competitor for the provision of services.... [P]rivate mini-governments now outnumber all other forms of local government combined. With the private taxes they gather — heading toward ten billion dollars a year — community associations are buying everything from private cops to sanitation services to entertainment to communal computers.[8]

By the end of the decade community associations are expected to collect about $20 billion a year in revenues, placing them among the largest economic centers of activity in the nation. They may soon come to represent more financial power than all elected local governments in the United States combined. A number of questions are raised by such facts:

> There are important public policy, political and legal issues here. If a condo community has its own private cops, its own private entertainment, its own services, why should it care if the city across the river has no cops, no services, no arts? ... Down that road are private services for those who can afford them and not much at all for those who cannot.

Arts advocacy focuses on the important role played by culture in the civic life of a community. If the communal aspects of civic life are eroding, what will be the consequences for public funding of the arts and local support by individuals? Many of these planned communities provide a variety

of leisure activities for residents. Will people ever want to leave the confines of such fortress-utopias? As we become aware of these changes, we must determine whether privatization offers any opportunity for the support, and possibly for the content, of our artistic work.

## Technology

There is no question that technology is having an impact on the idea of "civic life" by contributing to the increasing privatization of society. Witness the new stay-at-home trend. A recent article in *New York Magazine,* entitled "Couch Potatoes," cites an April 1986 Gallup Poll survey that included the question, "What is your favorite way of spending an evening?" One third of all Americans surveyed chose television as the preferred means of entertainment; 14 percent gave "resting and relaxing" as their favorite activity, a figure nearly double the percentage in 1974.[9]

Americans allegedly watch an average of seven and one-quarter hours of television a day. With the public spending eight hours at work, eight hours sleeping, and seven and one-quarter hours watching TV, perhaps we should be planning 45-minute arts activities! Due to the plethora of channels offered by cable television, the networks' share of prime-time viewers dropped to 77 percent, from about 92 percent in 1979. But nothing can compare with the growth in popularity and availability of the videocassette recorder. VCR penetration is currently more than 50 percent and climbing. In 1986 the number of videocassettes rented matched the number of movie tickets sold. This growth occurred in just five years. The home computer that many use for work is also a source of entertainment with its myriad games, puzzles, graphics and music programs. Of course, stereos have been part of the American way of life for years; now they have been replaced in some homes by the technically superior compact disc players.

In short, technology provides us with a number of compelling reasons to stay home. The arts must compete with these instant-entertainment centers in people's homes. Will those of us in the arts have to work ever harder to create the sense of an "event" worth leaving home for?

## Arts Organizations and Leisure Choices

No one could have predicted the proliferation of artists' organizations that has taken place and that many of us see as very positive. But we have spent very little time analyzing how this growth affects our ability to distinguish ourselves from other organizations, either to the funding community or to potential audiences.

In addition, admission prices to arts events have risen rapidly in the past five to ten years, forcing even committed arts-goers to make choices. We have always been aware of competition with other spectator activities for the entertainment dollar, but more and more people are now involved in participatory activities, including amateur sports, health and exercise clubs, and life-long learning. Of the 12.5 million students enrolled in higher education, more than five million are adult learners. Civic and social organizations compete for people's time. Cooking at home for invited guests and restaurant-going, both reportedly on the increase, are competitors for money and time as well.

## Summary

What are the consequences for the arts of all these changes? Rather than appealing to an ever-widening, racially and economically diverse audience, will we be appealing to an even whiter, wealthier audience than before? An article in the April 20, 1987, issue of the *New York Times Magazine,* entitled "Art Fever: The Passion and Frenzy of the Ultimate Rich Man's Sport," seems to suggest that this has already occurred.[10] Will we see a further reduction in the role of the arts in society, one in which they perform a purely decorative function, as handmaiden to a social and business elite?

In a time of increasing technological sophistication, with its great potential for isolation and alienation, perhaps the arts can find a deeper purpose — helping our communities and our society celebrate and examine what these changes mean for us. Artists' organizations have never been afraid to tackle serious issues, and it is certain that the sweeping changes we are experiencing will continue to surface in the artwork we create.

What is required is a re-examination, in light of these changes, of the way we have been doing business. We can take nothing for granted. We may have to begin thinking in new ways, resurrecting some of the ideas we have discarded. We must work "smarter" than in the past. This time of change can be quite frightening, but it offers great opportunity for regeneration.

## WHAT NEEDS TO BE DONE

The depth of need for appropriate technical assistance for artists' organizations was well stated by Jock Reynolds of the WPA in Washington, D.C. He spoke of the desire to "consolidate efforts and energy, to focus purpose with clearer form." This should be the goal of any serious technical assistance program. Reynolds went on to say that, "for artists working in artists' organizations, these desires can be felt when pondering methods for

achieving a purposeful and perhaps sustaining institutional future for 'alternative' forces in our culture."

However, he cites obstacles to this goal. Very few people running artists' organizations have received any formal training in administration, fundraising, management or other organizational skills:

> They continually rely on their wits, learning from many mistakes to achieve whatever organizational advancement is possible under the immediate circumstances. Progress comes from a blend of intuition, utter faith and often luck. This is not an uninteresting learning process, but it can be debilitating and exhausting to the point of no return. Many know this. Many have left the field.

Reynolds raises a series of important questions in his essay, questions that bear directly on the future of the field. Who can help artists besides other artists? Should organizations hire consultants to help? Should artists take courses and training seminars to master administrative skills? How many years should they train to become masterful? How will they keep their own artwork alive during this learning process? Should artists relinquish control and hire nonartists for their organizations? Can nonartist staff members become "artist-sensitive," and can staff artists put aside some of their prejudices against these "professionals?" Should artists' organizations link up with an institution that can provide administrative services? Reynolds concludes that artists working in organizations "must acquire advanced institutional skills themselves and/or hire other professionals to work with them now and in the future."

Any organization existing in a time of change requires technical assistance that is nonformulaic, that promotes ongoing self-examination by the organization. Jeff Hoone of Light Work in Syracuse, New York, asserted that, "if we look at artists' spaces collectively we will find that there are as many different programming and management styles as there are individual personalities behind those programs." In some instances, artists' organizations have rejected all technical assistance, perceiving that much of it promotes a "cookie-cutter" approach to solving administrative problems.

There has been a tendency to think that technical assistance is about how-to's — how to develop a board, how to design a good brochure, how to do a telemarketing campaign, how to conduct a capital campaign, how to write a grant proposal or press release. Most often, artists' organizations have used technical assistance to solve problems in specific areas, as a method or tool to achieve specific objectives.

We cannot use these tools effectively without comprehensive self-

analyses of our organizations. Without self-analysis, it is impossible to make informed decisions about which of these methods is appropriate for our specific organization, about which methods or tools conform to our values, which will help us build the kind of organization we want. In the absence of such analysis, we move blindly forward, applying someone else's prescription to the running of our own organizations.

Most organizations believe that more money would solve their problems. But in my ten years of working with artists' organizations, I have discovered that management is often of the crisis variety — and, consequently, money is actually being wasted on a daily basis. This happens for a number of reasons. Because most organizations have not engaged in a structured process of self-analysis, research into the local community has not been done, organizations are haphazard about building and maintaining their mailing lists, and very few internal reporting mechanisms are as sophisticated as they need to be. This can be as true for a large, well-financed organization as for a small one.

## Technical Assistance for the Future

Technical assistance for the future must assert and reassert the centrality of artists in the decision-making process. Some organizations have taken such steps. For example, it is interesting to note that several artist-driven theaters in Minneapolis require board members to "apprentice" and to sign contracts. Some have mandated majority control of the board by founding artists (51 percent of the votes); others have given board artists veto power. Some have instituted all of these policies. Such requirements have not stultified their board development.

Technical assistance for the eighties and beyond must provide a way of thinking, a framework for problem solving and informed decision making. It must help organizations to discover what is appropriate, help them to articulate clearly for themselves and their constituencies the individual paths they select. Effective use of tools and methods is important, but the decision to use them must evolve organically, must be the result of a sequential process of self-examination. An organization working from the center outward will be in alignment; its growth and development will be appropriate.

This process begins with the organization's unique mission. What is the philosophy, the aesthetic, that propels the organization? The arts field is littered with over-general mission statements — "McMission statements" — that communicate very little about the organization's particular point of view, what it will or will not present. Often problems perceived as coming from other organizational areas can quickly be traced to an unclear mission,

leading to confusion among staff, board and community. Fearing rejection by funding sources or potential board members, we begin a process of self-censorship in our language of self-description. Or we use jargon that has meaning only for insiders, that confuses or even alienates others. Generalized statements and jargon must be rejected in favor of more precise, evocative language.

As important as language is the human force at work in the organization — the executive producer, an artists' collective, a single artistic director, a team of artistic staff, the board. Finally, most important of all is the work itself and the work process.

Previously, technical assistance ignored the role that these three central components must play in management decisions. Yet the mission, the human force at the center of that vision, and the nature of the organization's work determine the answers to a number of key questions:

— What is the appropriate size of the organization?

— Who are the appropriate audience groups and funders?

— What specific tasks need to be done?

— What human resources are necessary to accomplish the tasks?

— What financial resources are necessary?

— What tools are appropriate?

— What structure will tie it all together?

— What are the appropriate criteria to measure success?

Answering these questions, using this process, an organization's "stakeholders" — as they are referred to by Susan Wheeler of Printed Matter in New York City — can be clearly identified, and the "stakes" more clearly defined. Wheeler points out that "often, during the elucidation of the 'stakes,' a deeper problem is uncovered that demands addressing first."

Careful and honest self-examination can shed light on a number of issues, such as whether to be profit or not-for-profit, whether an organization needs to grow and how it can grow, whether it should outlive the founders' energies, who might be appropriate for the board, whether a hierarchical structure or an alternative one would be more effective for the organization, whether the current allocation of duties is efficient, and whether sending out 50,000 brochures or 250 handwritten notes makes more sense.

An appropriate structure should emerge from this process, a structure congruent with the organization's purpose, values and work. "Ultimately," as Naisbett and Aburdene assert in *Reinventing The Corporation,* "there is

no pat answer. New structures, no matter how brilliantly designed, cannot be applied top down. Each new model must be custom-fit to the company and its specific needs."

Furthermore, as these areas are clearly defined and the criteria for success articulated, the organization is no longer seen as in competition with other community organizations or arts organizations. A healthy "ecology" emerges that recognizes and celebrates the diverse sizes and shapes our organizations will, and should, take—a diversity that has always been a hallmark of artists' organizations.

Self-examination helps an organization define its current status, so that it can design appropriate one-year, three-year and five-year goals. Obstacles to achieving those objectives can be assessed and strategies developed to overcome the obstacles. This is the prelude to effective planning.

## Components of a Technical Assistance Program

Beginning with an exploration of the current environment and the broad cultural trends at work in the community, and following this with a rigorous self-examination, an organization will then be ready to address the question of technical assistance. A valid program of technical assistance must be comprehensive. It must include community relations and communications, institutional development and fundraising, financial management, human resource development and planning.

These broad subject areas are best addressed by small groups so that the participants can become ongoing resources for each other. If possible, group workshops should include people working in the field who have experienced "success" in a particular area. It is not necessary that all workshop facilitators agree; in fact, a diversity of opinion and approach should be encouraged. It is critical, however, that the workshops generate "homework" and that they are followed by one-on-one consultations to make the general information discussed in the workshops relevant to each organization's specific circumstances.

The program of workshops outlined above requires a two- to three-year commitment on the part of an organization, the assumption being that during this time the organization continues to do business which, in turn, informs the workshops in a healthy way. It is best to schedule workshops three to four months apart, with one-on-one follow-up consultation in individual subject areas four to six weeks after each group session.

If Jock Reynolds's assessment of the state of the field is accurate, we are ready for this kind of technical assistance. But it would be misleading to suggest that the process outlined above is a painless one, that it is fast, that it is inexpensive. It requires rigorous self-analysis and eschews the "quick fix." But in the situations that I have observed, the process was highly effective. My hope is that this kind of technical assistance program will help artists' organizations to achieve the objective that Reynolds articulated: the ability to "consolidate efforts and energy, to focus purpose with clearer form."

Many of the ideas suggested in this essay result from a consideration of the changing environment; from the realization that we need to respect diversity of purpose, organizational style and structure; and from recognition of the fact that not only are cooperative projects cost-effective, but they also increase the visibility and impact of the artwork of all who participate.

Coming up with good ideas is the easy part. In fact, one of the problems with technical assistance today is that a new idea can sound *so* good that an organization may be seduced into putting the innovation into practice without first considering it in the context of the organization's overall mission, plans and strategies. This can completely derail an organization. There are many examples of this. For instance, some foundations, in a sincere effort to help small companies stabilize themselves, have instituted management assistance grants. But often, important questions are overlooked. Rarely are increased salaries for artists included in the funding package. Frequently, the newly hired manager will be making twice the salary of artists who have been doing the administrative tasks for years for little or no pay. Questions about how those artists will feel about such salary discrepancies are rarely raised. This influx of money can as much as double an organization's budget, which may cause real problems if there is no long-term plan to assure continuance after the grant period. Also, the artists may gradually and subtly be removed from the central focus in the organization.

This does not mean that the idea of staff support grants is a bad one. It simply means that for each organization, appropriate staff support means different things. Old-style technical assistance would say, "This is an exciting organization artistically. What it needs is a manager to whip it into shape." The new organizational assistance approach asks, "What kind of staff support would be most appropriate to help this particular organization operate in a way that is compatible with its unique mission and goals?" The shift from technical assistance that addresses only isolated areas, such as staffing, fundraising, marketing, planning or the use of volunteers, to organizational assistance that sees each organization's needs as unique re-

quires a marked change in the thinking of those offering management assistance programs.

The body of generic information offered by old-style technical assistance can still be of value. But basic information in each area of management — how to do research on your current audience or community, the components of a well-run membership campaign, how to maximize the use of volunteers, how to plan effectively — can be disseminated most effectively to organizations with shared needs. As discussed earlier, such group work encourages individuals and organizations to see each other as resources.

In moving from technical assistance to organizational assistance, contextual issues that traditionally have not been raised must now be confronted. We must ask such questions as: What message would a large mass mailing send to our current audience? How will moving from a 100-seat performance space to a 500-seat space in a new neighborhood affect the relationship we have built with our current audience? What will the long-term impact be on our organization if we slowly withdraw the policy-making role of the artists on our board?

Most arts organizations need a comprehensive program of management assistance. It is impossible to talk about effective marketing if there is no agreement about the organization's mission, if the staff is not communicating effectively with each other, if research on the current audience and community is nonexistent or haphazard. Management assistance that develops a way of thinking and a process of ongoing self-analysis, guarantees that an organization will ask itself the tough questions continually, not just in moments of crisis — many of which would have been preventable with a commitment to rigorous self-analysis.

Ideally, organizations should have access to this kind of comprehensive assistance when they are young, since it is designed to help them achieve greater clarity of purpose and to help them develop in a way appropriate to their mission. Early access to training helps organizations maximize the resources available to them. While most organizations cite money as their most pressing problem — and more money is always necessary to increase the effectiveness of artistic programming — the amount of money wasted by the administrations of both large and small organizations is shocking.

## CONCLUSION

Clearly, both mature and younger arts organizations can benefit from a well-designed program of appropriate, comprehensive organizational assistance. In addition, extraordinary support for organizations at critical points

in their development is an idea worth exploring. One example is the advancement program developed by the Expansion Arts Program at the National Endowment for the Arts in which supplementary financial support was accompanied by a year of technical assistance to insure the most effective use of the additional funding. Conceptually, such "artistic advancement" programs make sense: to help organizations at critical points in their development, extraordinary financial support is offered along with management assistance to assure effective use of the funds. But in practice, important contextual issues frequently are overlooked, and often a single model for organizational development is promulgated, which was the case with the Arts Endowment program.

A new, more effective kind of "artistic advancement" program would raise contextual questions with recipients so that the consequences of decisions could clearly be seen. Artistic advancement, not institutional self-perpetuation, would be the goal. Such a program would recognize that growth and development will be as varied as the organizations themselves. There would be no financial minimums or set categories into which organizations must artificially "stuff" their needs in order to qualify for assistance; the program would be flexible and highly individualized. Those in charge would always ask: How will this support help this organization to help itself? Is it possible that this support might put the organization in a vulnerable position in three, five or ten years? Can this support have substantive impact even if the organization sees no need to continue to exist indefinitely?

A comprehensive program of organizational assistance, as opposed to a "band-aid" approach, and a personalized, flexible "artistic advancement" program, with management support geared to an organization's unique artistic vision, could strengthen the arts community enormously. It could help artists' organizations to play a role in the creation of a humane, pluralistic twenty-first-century America.

## NOTES

1. Alvin Toffler, *The Culture Consumers: A Study of Art and Influence in America*. (New York: St. Martins Press, 1964).

2. Don Gevirtz, *The New Entrepreneurs: Innovation in American Business*. (New York: Penguin, 1985).

3. The "Rochester Gathering" refers to the meeting of administrators and artists hosted by the Visual Studies Workshop in Rochester, New York, from July 25 to 27, 1986. A selection of papers and related documents

from the meeting, called "The Visual Artists' Organization: Past, Present, Future," is contained in *AfterImage*, Vol. 14, No. 3. October 1986. Comments by Leon Denmark, Mary MacArthur Griffin, Jeff Hoone, Leonard Hunter, Nello McDaniel, Jock Reynolds, Susan Wheeler and Terry Wolverton, referred to in the text, are from that meeting.

4. John Naisbett and Patricia Abardene, *Re-Inventing The Corporation: Transforming Your Job and Your Company for the New Information Society.* (New York: Warner Books, 1985).

5. Marilyn Ferguson, *The Aquarian Conspiracy: Personal and Social Transformation in the 1980s.* ( New York: J.P. Torcher, 1985).

6. Alvin Toffler, op. cit.

7. Richard Louv, *America II.* (New York: Penguin, 1985).

8. Ibid.

9. D. Blum, "Couch Potatoes: The New Night Life," *New York Magazine,* (July 20, 1987), pp. 24-30

10. D. Smith, "Art Fever: The Passion and Frenzy of the Ultimate Rich Man's Sport," *New York Magazine,* (April 20, 1987), pp. 34-43.

# SUPPORT FOR ARTISTS BY INSTITUTIONS:
## Comment and Discussion

## CHARLES BERGMAN

The officers of the Pollock-Krasner Foundation have a very special commitment because of the desire expressed by Lee Krasner in her will that an international foundation be established to provide help exclusively to individual artists—worthy and needy artists. That is the foundation's mission and mandate, and I would like to encourage others to emulate it.

The foundation is very young, and in many ways we are emulating the wonderful example of the Adolph and Esther Gottlieb Foundation. To date, we have given 285 artists a total of $2,130,000, and there is a lot more money to give away. But we are overwhelmed, as is the Gottlieb Foundation, by the avalanche of applications that pour in to us from everywhere.

We are limited to painters, sculptors, graphic and multimedia artists. Initially we made a few grants in fine-art, still photography and crafts, but we withdrew from those two areas because the demand in the four areas we have designated was overwhelming, and we thought that Lee Krasner would have preferred that we narrow the focus. But there is such an immense need among individual artists in all the disciplines. Our chairman, Jerry Dickler — a distinguished art lawyer — and I have been quietly working with some other wealthy artists to explore the possibility of their following the example of Lee Krasner and Jackson Pollock.

When you establish a foundation whose only criteria for support are work, worth and need, you must scrupulously guard against any possibility that the foundation might commit even the subtlest kind of discrimination. We never see an artist face to face; we never visit a studio to see work in progress. Regrettably, we never see original works of art. If we did that for any artist, we would have to do the same for artists throughout the world,

and that would not be possible. So it is through slides, an application and a sensitive, compassionate and thorough investigation that we do our work.

This business of deciding who is worthy and needy is very pretentious. Who are we to play God and designate that someone is worthy or not, or needy or not? When we turn people down, we are very careful to make it clear that they are free to reapply at any time. Candidly, there are many people who apply to us who are not worthy or needy by any standards, but who are we to say that to them? It could be devastating for someone who believes in his or her ability and who is convinced of his or her need. Needless to say, need is much easier to define than merit, but whatever our reason for not making a grant, we are very, very careful about how we handle the applicant. I am pleased to report that we have been getting letters from people who have been turned down, thanking us for the respect that we have shown for the dignity of the struggling artist.

## TED POTTER

I am the director of an artists' support system in the southeast: the Southeastern Center for Contemporary Art, or SECCA. SECCA identifies and brings into sharp focus exceptional artists living in our eleven-state area.

SECCA is also the founding institution for the Awards in the Visual Arts, the national awards program for artists from coast to coast. Every year, the awards program reaches into all fifty states, along with Puerto Rico and the Virgin Islands, and asks top professionals in the field of contemporary art to identify artists of significance who need and deserve recognition. After the nomination process is completed, a national panel makes the ten awards.

This program goes beyond simply giving money to artists. A grant is always greatly appreciated, but often it is an anonymous act. The awards provide money and *recognition* — and they put art on the line by bringing it to the attention of the public through a major exhibition that travels across the country each year. The accompanying catalogue provides documentation of the artists' recognition, and the exhibition and catalog together bring the artworks to a wider audience.

In addition, the program gives each institution that hosts the show a $10,000 purchase award to enable them to buy the works of the exhibited artists for their permanent collection. Most institutions acquire contemporary art from a list of superstar artists. The Awards in the Visual Arts program allows them to take a harder look at other artists, artists who would not necessarily be considered without the attention the program brings to them.

The SECCA Awards in the Visual Arts program also has an important

data collecting component. Every year our panel of outstanding curators, critics, artists and art directors from across the country nominates five hundred artists for recognition. Only ten awards can be given, but biographies of all the nominees go into a computerized data base. The program is now in its seventh year, and as it continues to grow it will become an incredible resource for determining what artists are doing, what the professionals in the field think about them, and why they are significant and should be recognized.

Support and recognition are primary needs of the artist, along with shelter and sleep and love. Artists also need the market; it confuses them, it scares the hell out of them, but it is part of their waking life. The artists who participate in the noncommodity production of art are in a special market. It is not the same as the commercial market, but it is a market nonetheless. Every human endeavor, on whatever level, involves a market.

Artists are directly affected by the relationship between supply and demand in their market, and the supply of artists is very high and growing. There is hardly a university anywhere in the country now that does not have a visual arts graduate program, and that is very scary. Every spring the universities produce hundreds of MFAs. Where will they go? What will they do? What are their expectations? You can't consider need without considering expectations. What do the artists expect? What do we expect? There's a center down in Florida that brings in master artists of great reputation three times a year. Three masters—one in visual arts, one in dance, one in theater—come together with paying students who come by the droves to study with the masters. But as I see it, the expectations of the center and students are not at all the same.

One new trend that I find encouraging has to do with self-sufficiency. In the visual arts, the curators are in control; they are the power brokers. But artists are becoming more resilient, more self-sufficient. They seem to be taking more control of what happens to their work beyond the studio, which is very healthy. In the big picture, we curators, administrators, directors and art dealers are all really flight attendants for this thing called art. We can lose touch with that sometimes, and we need to keep it in mind. Art and the creative artist are what it's all about.

## BARBARA PRICE

In 1956 I married an artist who was twenty years older than I. He had been an emerging artist in the forties, and he showed his work in New York in the fifties. I became his manager—a manager who supported him in the details of his career—but I, too, was an artist, and I wanted to do the same thing he was doing. Not unlike many women whose mates die earlier than they, I was

given the gift of an entire estate to manage after my husband's death, which I still do, twenty years after his passing away.

I began with this bit of personal history because it points to what I call a "generational-change gap." It would have been very difficult for my husband to envision putting his slides together and going to some institution to seek support. After the market in New York changed from Abstract Expressionism to Pop Art, just taking his portfolio out was a humiliating enough experience. And the isolation that he chose for himself was something that I think a great many artists have experienced.

I now work in an institution, a college of art, which employs close to ninety-five practicing artists—the dual-career people. They are vitally involved as artists and at the same time are engaged in the very taxing profession of teaching. They range in age from thirty-five to seventy, so they include artists who were emerging in the sixties. At that time, artists were able to finish undergraduate school, complete a master's program, and then get a teaching job with very little effort. I remember the trouble my husband had at the University of Alabama because they didn't have a genius clause and he didn't have degrees, so he had to watch an MFA youngster—who had been in art for maybe six years—leave and get a job at the University of Kentucky at a higher salary than my husband was getting at the University of Alabama. During this period of time, there were tremendous opportunities in academia for artists with MFAs, so they didn't have to think about grants and resources and alternative activities to support themselves. Now that has changed.

The young artists who are evolving today and those who were emerging in the late seventies and early eighties are a different breed. They have learned how to prepare themselves in many different ways for a long life and career in the arts. They do not expect the same kind of patronage that went on in the fifties. They expect patronage, but it is a patronage they are defining themselves, and they are learning how to manipulate it. They are entering into the world of small business. There are so many things that they have to do to maintain themselves as individuals, and they have a lot of decisions to make. But one way or another, they find their way through all the myriad resources that exist today—resources and support structures that we take for granted now but which, for previous generations of artists, did not exist.

What does today's college of art do? The most important thing is that we concentrate on the emerging artist, the artist who is not only going to articulate our culture in the future, but who will also shape it. These artists will make a contribution to our economy, as artists have always done, and this is something that we too easily forget. For every dollar that is given to an artist, three dollars go back into the economy. There isn't a community or

neighborhood in which an artist resides that has not benefited. Artists don't have Swiss bank accounts. I don't think many of us have savings accounts. Whether we have dual careers or not, our dollars go right back into the economy, and I think that's a factor many people in politics forget.

A college of art also feeds the economy in many different ways. First, we develop art makers. We create an environment in which young people who aspire to enter a very taxing and demanding field are given the opportunity to study with individuals who have made their way through this same minefield, so to speak, and have managed to come out the other end. As an artist on the faculty, you play a mentorship role; no matter how many students you are teaching, you actually are doing tutorials. If you have a class of twenty-five students, you are doing twenty-five tutorials. It is a highly individualized program, and the institution takes the position that you have to teach more than just art. You have to teach your students how to build the skills that will enable them to make a lifetime profession and commitment out of their art.

We also develop art audiences. The MFAs and BFAs that we graduate will not be primarily makers of art. However, I think these graduates are responsible for the large audience that the recent Harris poll identified and for the much greater appreciation of what the arts mean to our society. I think the continuing education programs offered by art institutions and museums have given people who do not commit their lives to art the opportunity to understand that making art is not just therapy; it is a rigorous and demanding intellectual pursuit. It is the equivalent of basic research in the sciences. Some of these continuing education students will adopt an artist— a teacher they like or an artist they become involved with—and make their first purchase.

Recently, my president and I were doing a report, and we decided to find out how many visiting artists we have in the course of a year. We had been thinking probably a hundred, but we found approximately five hundred social security numbers that we had processed in just this last year. We literally are supporting the artist community, and that includes emerging artists from California, Washington, Virginia, Philadelphia, New York and areas in between. We support them through residencies, grants for commissions, and programs we have developed to share their work with the public. For all of the funding that we receive from the Arts Endowment, the Maryland State Arts Council, the Metropolitan Life Foundation and the Mid-Atlantic Arts Foundation, we probably match every dollar with three dollars invested by us in artists, their activities and in sharing their work with the community.

We cannot be all things to all people; nor do we have to be. As a university we are a vital center in which communication among artists occurs, but

there is now also Maryland Art Place and a very active arts council and a very rich artistic community — a community beyond the university — in which there is a lot of interaction, a lot of involvement.

We are a part of the advocacy circle. Our president probably gives as much time to supporting the fundraising efforts of other arts organizations as he does to the fundraising that we have to do in our own institution. Our philosophy is that we will not thrive if one institution alone has all the resources. We have to create a community that can provide support on many different levels, in many different ways. Sometimes when you are hungry, you are not as generous with your colleagues as you might be otherwise, but when you are in a position to be able to provide assistance, as many of us are, then I think you can see the generosity of spirit begin to blossom.

Earlier, Ted Potter asked about the expectations of our graduates. When these young people come out with their degrees, what do they expect to do? In many institutions, at least 70 percent of the staff are artists, and they are training their students to organize themselves so that they will be effective at managing their careers. We have a very entrepreneurial group of individuals coming out of these institutions. They do not expect that somehow or other there will be an endless supply of resources out there.

Many times foundations and arts organizations can help out only for a moment. They cannot provide the resources for the long haul. Institutions such as ours, and the regional arts organizations as well, are trying to be much more responsible in this regard by giving these young people tools and alternatives with which they can provide for themselves. We are teaching them that having a dual career does not necessarily mean that you make less art. After all, what's the point of having all your time free to make art if you have no money for materials and supplies? This no longer means that artists have to wait on tables. There are many more opportunities and diverse choices for the artist today than ever before. They may go into arts administration or arts-related services.

In contrast, it would have been inconceivable for the man I married in 1956 to envision doing anything more than working in his studio, doing what he was doing at the university, and hoping that somehow an opportunity would open up for him, that someone would appear and look out for his interests. But the older generation of gallery owners, people like Leo Castelli, provided a quality of gallery support that we are not going to see again. They sustained the practicing artists of the fifties, and maybe through the sixties, but they are not there for today's artists.

The world for the artist is different now. And contemporary institutions can contribute to that world. We may not be able to provide individuals with all the support they need, but I think on the whole our concerns and our efforts are bearing fruit.

# DON RUSSELL

The stereotype of the independent artist as the outcast or the renegade is changing. The artist is getting much closer to society, and society is getting much closer to artists. The best example of this is the preponderance of public art, which I think of as a metaphor for the artist and the public getting closer together.

Fellowships are the best kind of support for artists because a fellowship may be the only real compensation an artist gets for making art. A fellowship buys time, and that is one of the most important needs for artists who are developing their work.

The artists' organizations are very important right now, even though they are not well known in the field. There are some two hundred of these institutions around the country functioning in various ways, and many of them have developed very good, concrete programming. While they generally do not give fellowships, they have demonstrated their commitment to individual artists by paying artists' fees for exhibitions and by commissioning new works. It is very difficult to raise money for fees and commissions, but they probably are as important as fellowships. These organizations also provide artists with access to tools — special kinds of equipment for photographers, for example, or the facilities necessary for ceramics or different kinds of casting.

Artists' organizations are committed to different types of audiences — nontraditional audiences — but this is an area that could be improved through better educational programs. Educational programming and documentation are two areas in which artists' organizations fall somewhat short. Nor is self-promotion one of their strengths.

Obviously, a definitive ingredient in the artists' organization is the decision-making role of the artist as a presence on the board; on some boards, artists constitute a majority. Also, the staff members at most of these organizations are artists, which is another important means by which the integration of artists into the organizational structure is maintained. Artist involvement will keep these institutions vital and hold them to a direction and purpose conducive to the support of individual artists.

Finally, older artists, as a category, are generally not involved with artists' organizations, which tend to be somewhat biased toward the new and more affected by the marketplace than they ought to be. This is unfortunate, and it is something that these organizations should address, particularly as they become more mature. Older artists would provide historical continuity and foster mutual respect among competing interests in the art world.

# DISCUSSION FROM THE FLOOR

**MILTON RHODES:** Who in society should support these artist-run organizations? Who should pay the bills for the organizations run by and for artists?

**TED POTTER:** Regardless of who *should* pay, we have trouble finding the funds anywhere. We get a lot of pats on the back, but funding is very difficult to come by. This year the Arts Endowment had an administrative budget of $17 million and a budget of $6 million for the visual artist. They should be doing more.

**RUBY LERNER:** It isn't only the visual arts organizations that are artist-run. It is performing arts organizations, too, and they face the same problems that visual arts groups face. It is going to be very difficult for any artist-run organization to get private-sector support. It is not just going to fall into our laps. At least historically that has not been the case. One of the things we have to push for is a more equitable distribution of *public*-sector support.

On another matter, I do a lot of marketing work, and one of the things I see is that many organizations are not doing a very good job of identifying their own constituency. They do not know who is walking in the door. They are leaping over these people and asking, "Where are the yuppies? Where is this group? Where is that group?" instead of focusing on the audience they have. I think it is possible to create a sense of a "stakeholdership" among the audiences that exist; they could be very supportive if they saw these institutions as a vital part of their lives and of the life of the community.

**BRUCE PAYNE:** It seems to me that visual arts organizations have had even more problems than performing arts organizations; part of the reason for this, organizationally and politically, is that in the performing arts, hierarchy is a fact of life. That is true in choreography, in orchestral work — really across the board. The visual arts organizations that want to remain entirely under artists' control should stay small and experimental. They should not try to have big budgets. The ones that need large-scale support, on the other hand, will have to reach out to the powers that be, where the money is. They will have to determine what is important to hold onto artistically and what is important to share with the broader community. Exhibitions cannot be solely in the hands of the artists if the organization wants to reach the larger community. If you want people to have a stake, you have got to give them a share of the power. Because of the ardent individualism that prevails in the visual arts, the organizations run by visual artists lack the political ex-

perience and the experience with hierarchy that organizations run by performing artists have. I think we will get past the growing pains we are experiencing right now, but not until many of the artists who are spending so much time on politics get back to their painting and their sculpture.

GEORGE KOCH: To answer the question, "Who is going to support these artists' organizations?" you must first define the kind of organization you are talking about. Is it an organization that is providing a service, or is it an advocacy organization? There is a real need for advocacy groups run by and for artists. History tells us that if you want something in this society, you have got to go out and get it for yourself. I get really angry about this. Artists are not able to articulate their own needs, and they have not supported those organizations and structures that do. When they have spoken for themselves on a regional or national basis, they have been able to cause some real economic changes—for example, the changes in consignment law on the state level. It was the small arts organizations in various states that brought this about, not the large organizations. In California, it was the arts organizations who got the resale royalties act passed. Those kinds of things put money in the hands of artists—particularly older artists, in the long run—and those are the kinds of things that need to be done.

STEPHEN BENEDICT: What has been the principal source of support over the years for Artists Equity?

GEORGE KOCH: Fees. We received one $3,000 grant from the NEA in the seventies, but we have applied every year for the last five or so and been turned down every time. They want to support producers of art, not advocacy organizations for the arts. That is true of foundations as well. Nobody wants to support advocacy.

CHARLES BERGMAN: I sit on a number of nonprofit boards, and with all due respect, I must say that artists' organizations can be deplorably naive when it comes to issues of governance, funding and marketing. It is amazing to see how masochistically resourceful they can be—despite the fact that they have not emulated their health, social service and cultural brethren. I recently joined the board of the Circle Rep, a wonderful New York theater company, and are we experiencing growing pains! The competition for the charitable dollar is infinitely more intense right now than the competition for the commercial dollar. Arts organizations are going to have the greatest struggle in their history, because everybody else is.

JACQUELINE SKILES: I want to say something about the Foundation for the Community of Artists in New York. In 1973, I became vice president and, very quickly, president, which I did not know was going to happen. Nor

did I know that there was no money. The organization survived, but not because of membership fees alone. We survived because by hook or by crook we were able to get some other talent—Michael McCann, for example.

I met Michael on the Lower East Side at a street fair where I was selling posters. He walked up to me and said, "These posters are silk screen and that's a health hazard." I asked him to explain, and he and I went to dinner. Later he wrote an article on health hazards in the arts, seven articles in all, for the *Art Workers News*—and we parlayed them into a booklet that ran to several editions. The publisher agreed we could pay him back later, and that was the start of our loan fund. Bill Keen, a sculptor who knew that we had been trying to get health insurance for artists for a long time, referred us to a broker who handled insurance for some other arts organizations. He got to Blue Cross when we never could have, and we finally got health insurance for our membership. It was the services we provided to our community that brought us fees. People did not just hand us money.

**JUDY BACA:** Ruby, you talked about the intentions of artists' organizations when they were originally founded. We are now in a second generation. What would you say about the new generation of leadership that has followed the founders?

**RUBY LERNER:** Leadership is a problem now. After I left Alternate ROOTS, it became apparent that we had done a very poor job of fostering the next generation of leadership for the organization.

**OLIVIA GEORGIA:** I am one of those second-generation arts administrators, and I have mixed feelings about your comments on technical assistance. My attitude is not as negative. We are able to do that kind of thing and, at the same time, involve community leaders and a diversity of people in building and supporting our organization. Rather than chastising us and telling us that is not the way for artists' organizations to institutionalize themselves, maybe people should concentrate on the positive aspects of that process.

**LINDA SULLIVAN:** The problem is that artists' organizations are trying to be all things for everyone. They are falling back on existing models, going after foundation and government grants and running big-splash fundraisers because they are trying to be producer, presenter and service organization. They need to look at different models and maybe pull back and redefine themselves. You can't get to Milton's question of who should support artists' organizations until they are better defined.

**RUBY LERNER:** The issue is one of consciousness in the decision-making process. Many organizations assume a direction without fully understanding its inherent assumptions and implications.

## ABOUT THE PARTICIPANTS

**Judith F. Baca** visual artist; artistic director, Social and Public Art Resources Center, Venice, California.

**Stephen Benedict,** director, Program in Art Administration, Columbia University.

**Charles C. Bergman,** executive vice president, the Pollock-Krasner Foundation.

**Tom Bradshaw,** acting director of the Research Division, National Endowment for the Arts.

**Richard Brown,** assistant director, Survey Research Center at the University of Maryland.

**Muriel Cantor,** professor of sociology, American University.

**C. Lynn Cowan,** Ph.D. candidate in political science, Johns Hopkins University; information systems consultant to state arts agencies, regional arts organizations and other nonprofit organizations.

**Sanford Hirsch,** executive director, the Adolph and Esther Gottlieb Foundation.

**George C. Koch,** visual artist; vice president, National Artists Equity.

**Ruby Lerner,** independent consultant, FEDAPT and the Pennsylvania Council on the Arts; former executive director of Alternate ROOTS.

**Bruce L. Payne,** director, Leadership Program at the Institute of Policy Science and Public Affairs, Duke University.

**Ted Potter,** director, Southeastern Center for Contemporary Art.

**Barbara Price,** vice president for academic affairs and the academic dean, Maryland Institute, College of Art.

**Don Russell,** president, for Arts Resources International.

**John P. Robinson,** professor of sociology and director, Survey Research Center, University of Maryland.

**Brann Wry,** director, Performing Arts Administration Program, New York University; executive editor, *Journal of Arts Management and Law.*

## ABOUT THE AMERICAN COUNCIL FOR THE ARTS

The American Council for the Arts (ACA) is one of the nation's primary sources of legislative news affecting all of the arts and serves as a leading advisor to arts administrators, educators, elected officials, arts patrons and the general public. To accomplish its goal of strong advocacy of the arts, ACA promotes public debate in various national, state and local forums; communicates as a publisher of books, journals, *Vantage Point* magazine and *ACA Update*; provides information services through its extensive arts education, policy and management library; and has as its key policy issues arts education, the needs of individual artists, private-sector initiatives, and international cultural relations.

The First Boston Corporation
Ford Motor Co. Fund
Gannett Outdoor
Goldman, Sachs & Company
Mr. & Mrs. John Hall
David H. Harris
Louis Harris
The Hartford Courant
Howard S. Kelberg
Ellen Liman
The Joe and Emily Lowe
    Foundation, Inc.
MBIA Inc.
Lewis Manilow
Merrill Lynch, Pierce, Fenner &
    Smith, Inc.
Mobil Foundation, Inc.
Morgan Guaranty Trust Company
J.P. Morgan Securities
Morgan Stanley & Co.
Morrison Knudson Corporation
New York Times Company
    Foundation
Pacific Telesis Group
RJR Nabisco
General Dillman A. Rash
David Rockefeller, Jr.
Henry C. Rogers
Mr. and Mrs. Leroy Rubin
Shell Companies Foundation
Schering Corporation
Allen M. Turner
Warner-Lambert Company
Whirlpool Foundation
Xerox Foundation

## CONTRIBUTORS
### ($2,000-$4,999)
Abbott Laboratories
Alcoa Foundation
Allied Corporation
American Electric Power
    Company, Inc.
American Express Foundation
Mr. and Mrs. Curtis L. Blake
Gerald D. Blatherwick
Edward M. Block
Borg-Warner Co.
Mrs. Eveline Boulafendis
Donald L. Bren
Bristol-Myers Fund

C.W. Shaver
The Chevron Fund
Terri & Timothy Childs
Robert Cochran
Mr. & Mrs. Hill Colbert
Mr. & Mrs. Donald G. Conrad
Barbaralee Diamonstein-Spielvogel
Mr. & Mrs. Charles W. Duncan, Jr.
Mrs. George Dunklin
Eastman Kodak Company
Emerson Electric
Ethyl Corporation
GFI/KNOLL International
    Foundation
Donald R. Greene
Eldridge C. Hanes
Mr. & Mrs. Irving B. Harris
Ruth & Skitch Henderson
Henry Kates
John Kilpatrick
Knight Foundation
Kraft, Inc.
Mr. Robert Krissel
Frank W. Lynch
Mr. & Mrs. John B. McCoy
Marsh & McLennan Companies
Monsanto Company
Robert M. Montgomery, Jr.
Velma V. Morrison
New York Life Foundation
The Overbrook Foundation
Mr. & Mrs. Thomas Pariseleti
Procter & Gamble Fund
Raytheon
Mr. & Mrs. Richard S. Reynolds III
Judith & Ronald S. Rosen
Sara Lee Corporation
Frank A. Saunders
David E. Skinner
Union Pacific Foundation
Mrs. Gerald H. Westby
Westinghouse Electric Fund
Mrs. Thomas Williams, Jr.

## PATRONS
### ($1,000-$1,999)
Morris J. Alhadeff
Mr. & Mrs. Arthur G. Altshcul
Mrs. Anthony Ames
AmSouth Bank N.A.
Archer Daniels Midland Co.

AmSouth Bank N.A.
Archer Daniels Midland Co.
Anne Bartley
Mr. Wallace Barnes
Bell South
Mr. & Mrs. Evan Beros
Binney & Smith
T. Winfield Blackwell
Houston Blount
Bowne of Atlanta, Inc.
William A. Brady, M.D.
Alan Cameros
Gary T. Capen
Mr. & Mrs. George Carey
Chris Carson
Mrs. George P. Caulkins, Jr.
Mr. Campbell Cawood
Mrs. Jay Cherniack
Chesebrough-Pond's, Inc.
Chrysler Corp.
Citizens and Southern
    Corporation
David L. Coffin
Thomas B. Coleman
Mr. & Mrs. Marshall Cogan
Cooper Industries Foundation
Mrs. Howard Cowan
Cowles Charitable Trust
Cummins Engine Foundation
Mrs. Crittenden Currie
John G. Crosby
David L. Davies
Carol Deasy
Jennifer Flinton Diener
Eugene C. Dorsey
Ronald & Hope Eastman
EBSCO Industries, Inc.
Mrs. Hubert Everist
Mary & Kent Frates
Stephanie French
Frederick P. Furth
Mr. & Mrs. Edward Gaylord
Mr. and Mrs. Edward Gildea
Lee Gillespie
Dr. and Mrs. John M. Gibbons
Mr. & Mrs. Robert C. Graham, Jr.
Lois Lehrman Grass
Richard M. Greenberg
Mr. & Mrs. W. Grant Gregory
Bernice Grossman &

Stephen Belth
R. Philip Hanes, Jr.
Mr. & Mrs. Joseph Helman
Mrs. Skitch Henderson
Edward I. Herbst
Admiral & Mrs. B.R. Inman
Mrs. Lyndon B. Johnson
Mr. & Mrs. Thomas Jolly
Alexander Julian
L. Paul Kassouf
Mrs. Albert S. Kerry
Shane Kilpatrick
Mrs. Roy A. Kite
Mrs. James Knapp
Henry Kohn
Mrs. C.L. Landen, Jr.
Mrs. Wilbur Layman
Fred Lazarus IV
Thomas B. Lemann
Robert Leys
Dr. & Mrs. James L. Lodge
Mrs. Robert Lorton
Mr. & Mrs. I.W. Marks
Mr. & Mrs. Peter Marzio
Mr. & Mrs. James W. McElvany
Florence D. McMillan
Tim McReynolds
Mrs. Michael A. Miles
Mr. & Mrs. Reese L. Milner II
Wendy & Alan Mintz
Mr. & Mrs. George Mitchell
Mr. & Mrs. Robert Mosbacher
Sondra G. Myers
Mr. and Mrs. William G. Pannill
Pantone, Inc.
Diane Parker
Mr. & Mrs. Scott Pastrick
Jane Bradley Petit
Mr. & Mrs. Harry Philips, Jr.
Philips Petroleum Foundation
Mrs. Arliss Pollock
Mr. & Mrs. John Powers
W. Ann Reynolds
William T. Reynolds
Mrs. Kay Riorden-Steuerwald
Mr. & Mrs. William A. Roever
Ronald S. Rosen
Mr. & Mrs. Eugene S. Rosenfeld
Rubbermaid, Inc.